100 ILLUSTRATED

Bible Verses

INSPIRING WORDS. BEAUTIFUL ART.

WORKMAN PUBLISHING • NEW YORK

Library of Congress Cataloging-in-Publication Data is available.

ISBN 978-0-7611-8566-6

Design by Janet Vicario

Cover illustration by Becca Cahan and Caitlin Keegan

Workman books are available at special discounts when purchased in bulk for premiums and sales promotions as well as for fund-raising or educational use. Special editions or book excerpts also can be created to specification. For details, contact the Special Sales Director at the address below, or send an email to specialmarkets@workman.com.

Workman Publishing Co., Inc.
225 Varick Street
New York, NY 10014-4381
workman.com

WORKMAN is a registered trademark of Workman Publishing Co., Inc.

Printed in China

First printing September 2015

10 9 8 7 6 5 4 3 2 1

For an explanation on the capitalization choices made in this book, please see page 206.

Old Testament

1 In the beginning, God created the heavens and the earth.

2 The earth was formless and empty. Darkness was on the surface of the deep and God's Spirit was hovering over the surface of the waters.

3 God said, "Let there be light," and there was light.

4 God saw the light, and saw that it was good. God divided the light from the darkness.

5 God called the light "day," and the darkness he called "night." There was evening and there was morning, the first day.

World English Bible

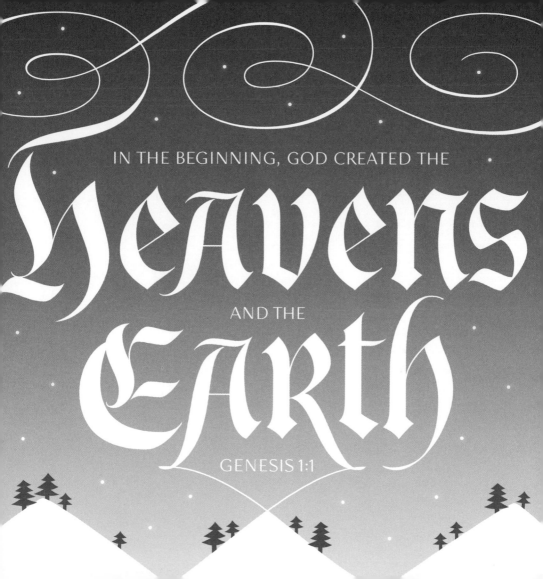

IN THE BEGINNING, GOD CREATED THE

Heavens

AND THE

Earth

GENESIS 1:1

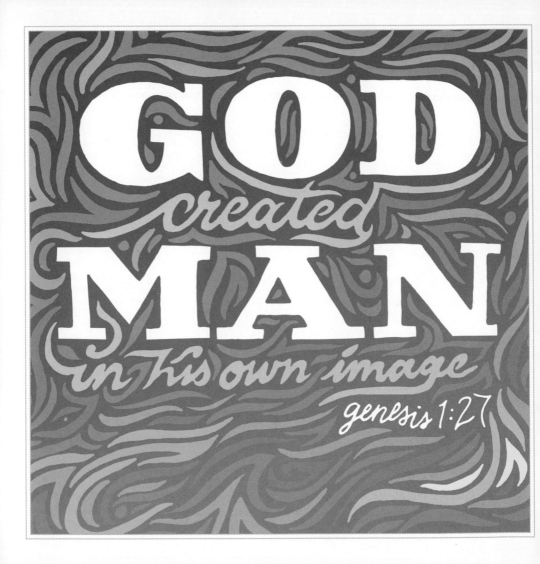

GENESIS 1: 26–28

26 And God said, Let us make man in our image, after our likeness: and let them have dominion over the fish of the sea, and over the fowl of the air, and over the cattle, and over all the earth, and over every creeping thing that creepeth upon the earth.

27 So **God created man in his own image**, in the image of God created he him; male and female created he them.

28 And God blessed them, and God said unto them, Be fruitful, and multiply, and replenish the earth, and subdue it: and have dominion over the fish of the sea, and over the fowl of the air, and over every living thing that moveth upon the earth.

King James Version

1 The heavens, the earth, and all their vast array
were finished.
2 On the seventh day God finished his work which he
had done; and he rested on the seventh day from all
his work which he had done.
**3 God blessed the seventh day, and made it holy,
because he rested in it from all his work of creation
which he had done.**
4 This is the history of the generations of the
heavens and of the earth when they were created,
in the day that Yahweh God made the earth and the
heavens.

World English Bible

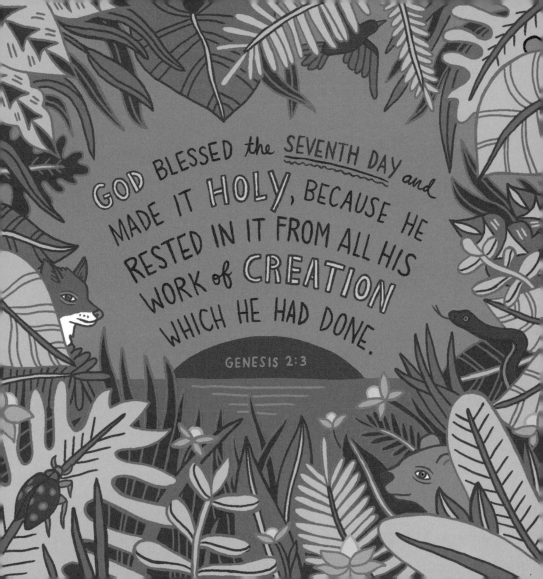

GOD BLESSED the SEVENTH DAY and MADE IT HOLY, BECAUSE HE RESTED IN IT FROM ALL HIS WORK of CREATION WHICH HE HAD DONE.

GENESIS 2:3

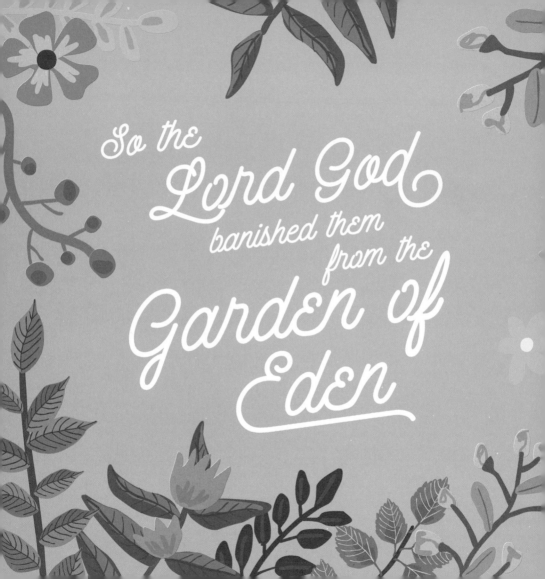

So the Lord God banished them from the Garden of Eden

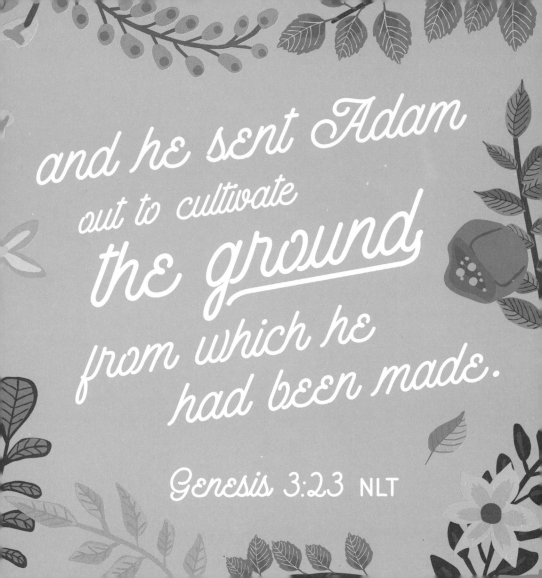
and he sent Adam out to cultivate the ground from which he had been made.

Genesis 3:23 NLT

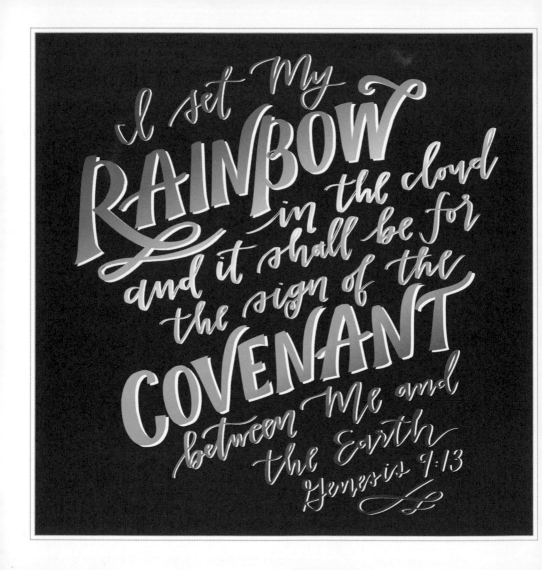

12 And God said: "This is the sign of the covenant which I make between Me and you, and every living creature that is with you, for perpetual generations:

13 I set My rainbow in the cloud, and it shall be for the sign of the covenant between Me and the earth.

14 It shall be, when I bring a cloud over the earth, that the rainbow shall be seen in the cloud;

15 and I will remember My covenant which is between Me and you and every living creature of all flesh; the waters shall never again become a flood to destroy all flesh."

New King James Version

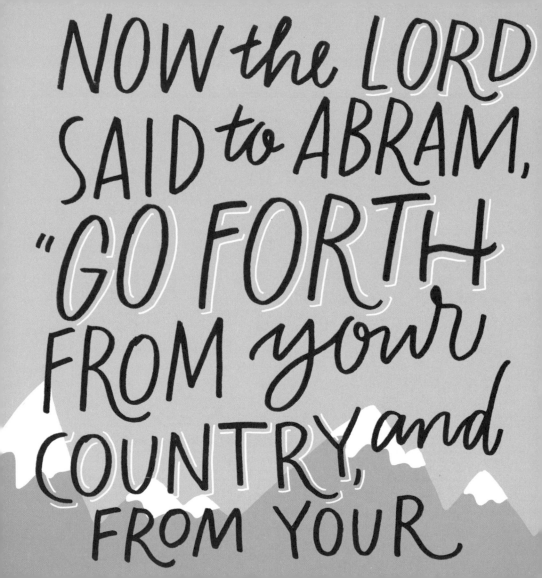

RELATIVES and FROM your FATHER'S HOUSE, to the LAND WHICH I WILL SHOW YOU."

Genesis 12:1 NASB

13 Then Moses said to God, "Behold, I am going to the sons of Israel, and I will say to them, 'The God of your fathers has sent me to you.' Now they may say to me, 'What is His name?' What shall I say to them?"

14 God said to Moses, "I AM WHO I AM"; and He said, "Thus you shall say to the sons of Israel, 'I AM has sent me to you.'"

15 God, furthermore, said to Moses, "Thus you shall say to the sons of Israel, 'The Lord, the God of your fathers, the God of Abraham, the God of Isaac, and the God of Jacob, has sent me to you.' This is My name forever, and this is My memorial-name to all generations."

New American Standard Bible

GOD SAID TO MOSES,
"I AM WHO I AM";
AND HE SAID,
"THUS YOU SHALL SAY
TO THE SONS OF ISRAEL,
'I AM HAS
SENT ME TO YOU.'"
EXODUS 3:14

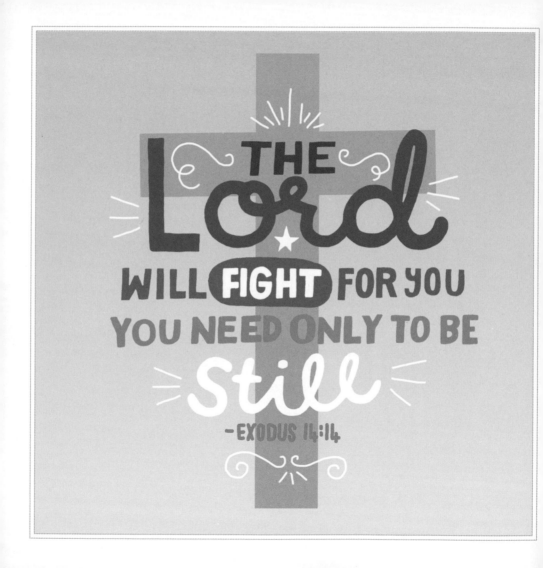

13 Moses answered the people, "Do not be afraid. Stand firm and you will see the deliverance the LORD will bring you today. The Egyptians you see today you will never see again.

14 The LORD will fight for you; you need only to be still."

15 Then the LORD said to Moses, "Why are you crying out to me? Tell the Israelites to move on. **16** Raise your staff and stretch out your hand over the sea to divide the water so that the Israelites can go through the sea on dry ground."

New International Version

1 Then sang Moses and the children of Israel this song unto the LORD, and spake, saying, I will sing unto the LORD, for he hath triumphed gloriously: the horse and his rider hath he thrown into the sea.

2 The LORD is my strength and song, and he is become my salvation: he is my God, and I will prepare him a habitation; my father's God, and I will exalt him.

King James Version

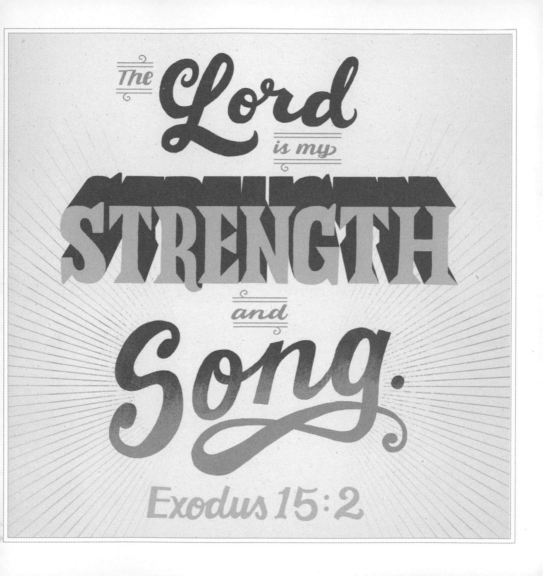

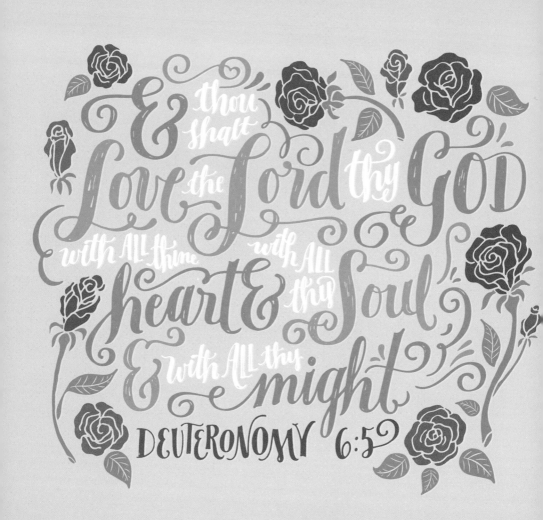

& thou shalt Love the Lord thy GOD with ALL thine with ALL thy heart & thy Soul & with ALL thy might DEUTERONOMY 6:5

DEUTERONOMY 6:4–7

4 Hear, O Israel: The Lord our God is one Lord:

5 And thou shalt love the Lord thy God with all thine heart, and with all thy soul, and with all thy might.

6 And these words, which I command thee this day, shall be in thine heart.

7 And thou shalt teach them diligently unto thy children, and shalt talk of them when thou sittest in thine house, and when thou walkest by the way, and when thou liest down, and when thou risest up.

King James Version

19 I call heaven and earth to witness against you
today that I have set before you life and death,
blessings and curses. **Choose life so that you
and your descendants may live,**

20 loving the Lord your God, obeying him,
and holding fast to him; for that means life to you
and length of days, so that you may live in the land
that the Lord swore to give to your ancestors, to
Abraham, to Isaac, and to Jacob.

New Revised Standard Version

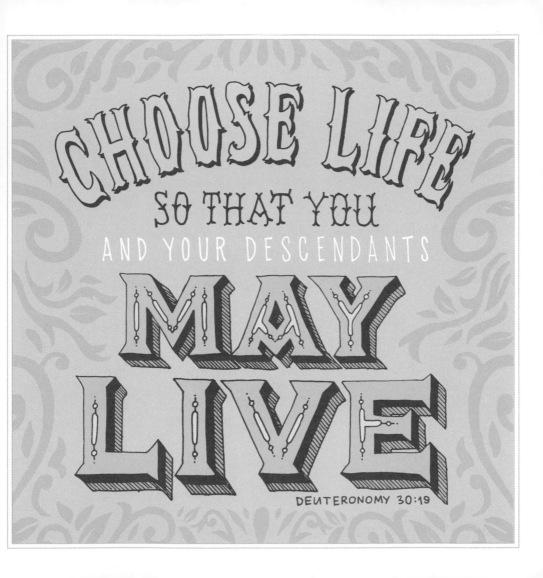

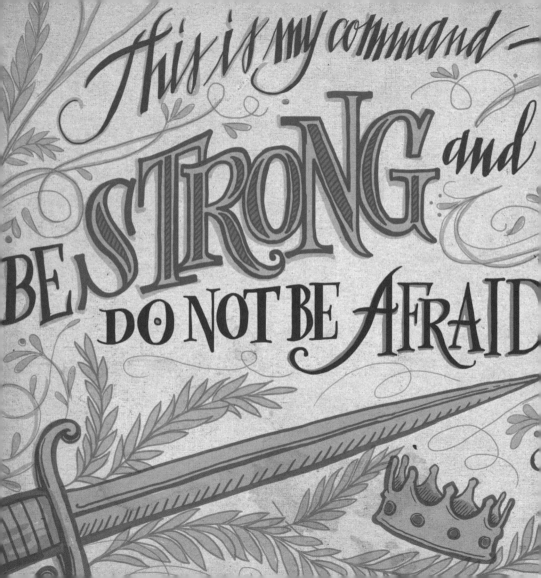

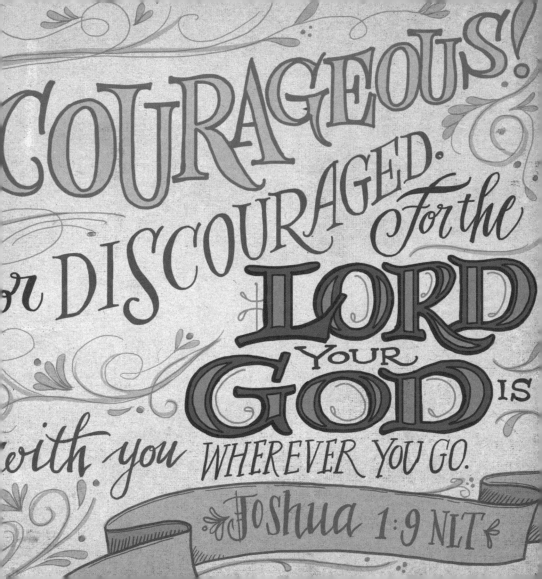

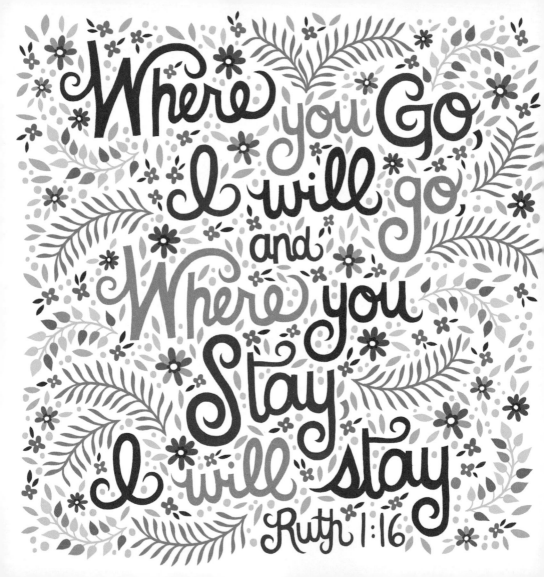

15 "Look," said Naomi, "your sister-in-law is going back to her people and her gods. Go back with her."

16 But Ruth replied, "Don't urge me to leave you or to turn back from you. **Where you go I will go, and where you stay I will stay.** Your people will be my people and your God my God.

17 Where you die I will die, and there I will be buried. May the Lord deal with me, be it ever so severely, if even death separates you and me."

New International Version

31 Let the heavens be glad, and let the earth rejoice,

and let them say among the nations, "The LORD is king!"

32 Let the sea roar, and all that fills it;

let the field exult, and everything in it.

33 Then shall the trees of the forest sing for joy

before the LORD, for he comes to judge the earth.

34 O give thanks to the LORD, for he is good;

for his steadfast love endures forever.

New Revised Standard Version

PSALM 18:1–3

1 I love you, O LORD, my strength.

2 The LORD is my rock, my fortress, and my deliverer,
my God, my rock in whom I take refuge,
my shield, and the horn of my salvation, my
stronghold.

3 I call upon the LORD, who is worthy to be praised,
so I shall be saved from my enemies.

New Revised Standard Version

1 The heavens proclaim the glory of God.
The skies display his craftsmanship.

2 Day after day they continue to speak;
night after night they make him known.

3 They speak without a sound or word;
their voice is never heard.

4 Yet their message has gone throughout the earth,
and their words to all the world.

God has made a home in the heavens for the sun.

5 It bursts forth like a radiant bridegroom after his wedding.
It rejoices like a great athlete eager to run the race.

6 The sun rises at one end of the heavens and follows its
course to the other end. Nothing can hide from its heat.

New Living Translation

THE HEAVENS PROCLAIM THE GLORY OF GOD. THE SKIES DISPLAY HIS CRAFTSMANSHIP.

PSALM 19:1

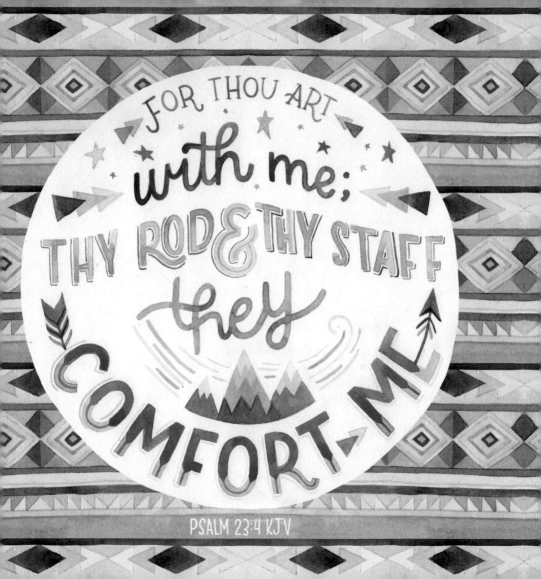

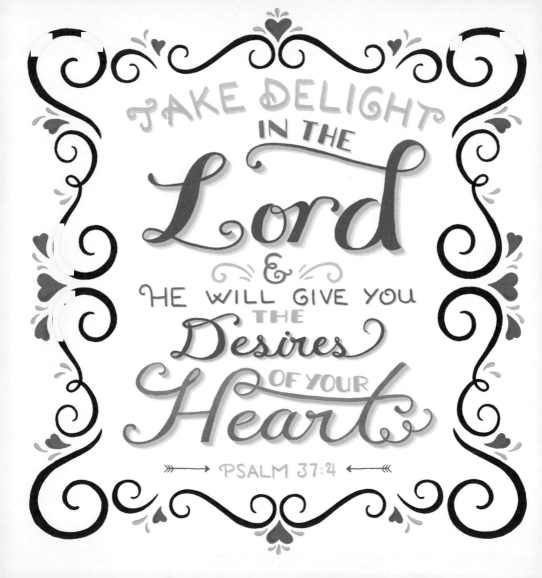

3 Trust in the Lord, and do good;

so you will live in the land, and enjoy security.

4 Take delight in the Lord,

and he will give you the desires of your heart.

5 Commit your way to the Lord;

trust in him, and he will act.

6 He will make your vindication shine like the light,

and the justice of your cause like the noonday.

New Revised Standard Version

1 As the hart panteth after the water brooks, so panteth my soul after thee, O God.

2 My soul thirsteth for God, for the living God: when shall I come and appear before God?

3 My tears have been my meat day and night, while they continually say unto me, Where is thy God?

4 When I remember these things, I pour out my soul in me: for I had gone with the multitude, I went with them to the house of God, with the voice of joy and praise, with a multitude that kept holyday.

5 Why art thou cast down, O my soul? and why art thou disquieted in me? hope thou in God: for I shall yet praise him for the help of his countenance.

King James Version

As the hart panteth after the water brooks, so panteth my soul after thee, O God.

Psalm 42:1

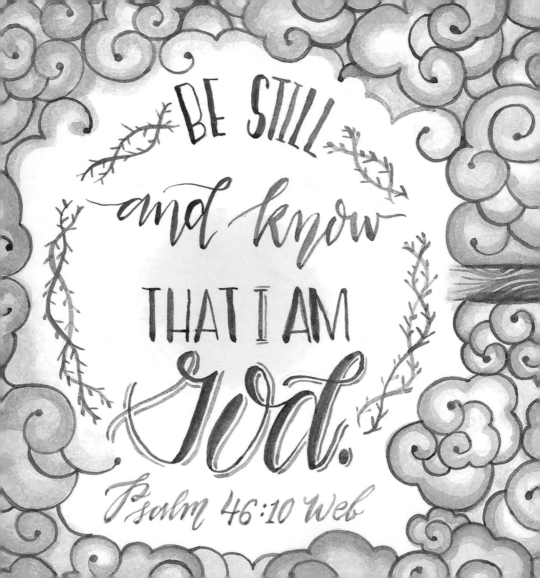

BE STILL
and know
THAT I AM
God.
Psalm 46:10 Web

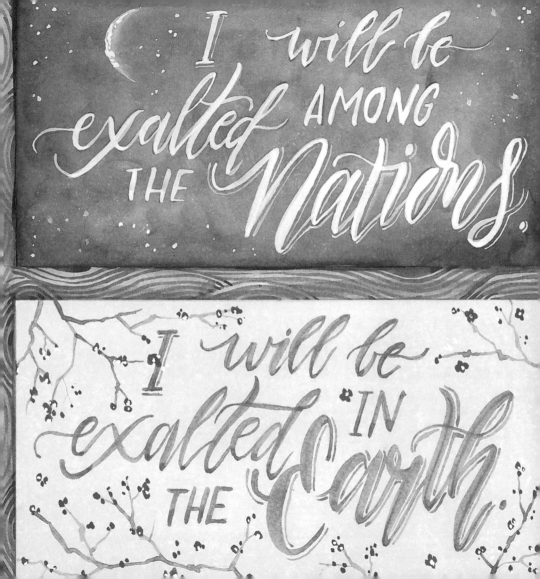

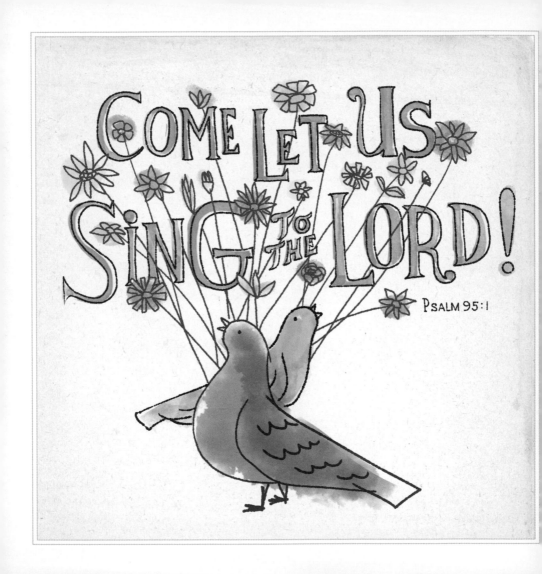

1 Come, let us sing to the LORD!

Let us shout joyfully to the Rock of our salvation.

2 Let us come to him with thanksgiving.

Let us sing psalms of praise to him.

3 For the LORD is a great God,

a great King above all gods.

4 He holds in his hands the depths of the earth

and the mightiest mountains.

5 The sea belongs to him, for he made it.

His hands formed the dry land, too.

6 Come, let us worship and bow down.

Let us kneel before the Lord our maker,

7 for he is our God.

We are the people he watches over,

the flock under his care.

New Living Translation

19 Open to me the gates of righteousness;

I will go through them,

And I will praise the LORD.

20 This is the gate of the LORD,

Through which the righteous shall enter.

21 I will praise You,

For You have answered me,

And have become my salvation.

22 The stone which the builders rejected

Has become the chief cornerstone.

23 This was the LORD's doing;

It is marvelous in our eyes.

24 This is the day the LORD has made;

We will rejoice and be glad in it.

New King James Version

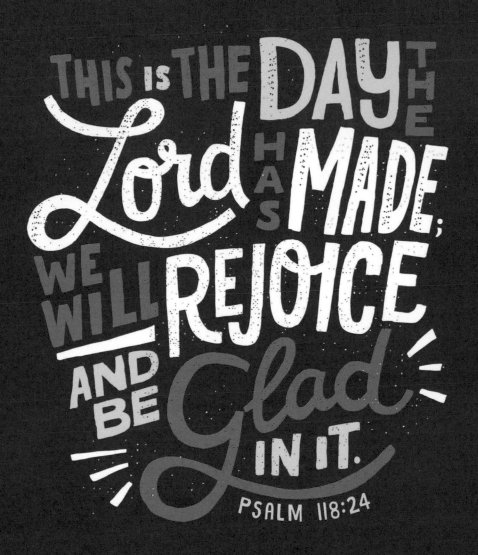

THIS is THE DAY THE Lord HAS MADE; WE WILL REJOICE AND BE Glad IN IT.

PSALM 118:24

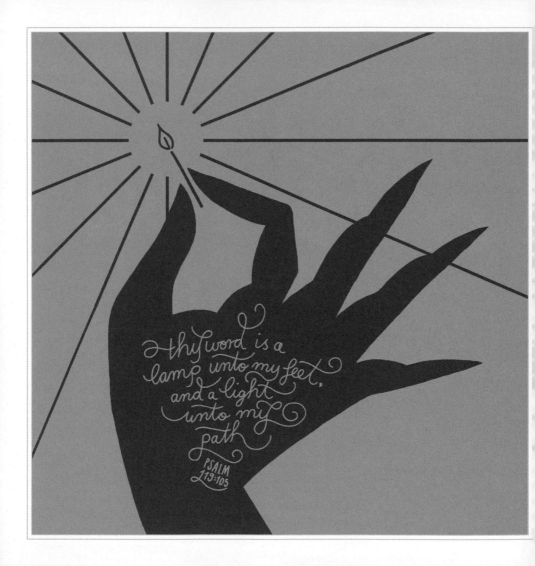

103 How sweet are thy words unto my taste!
yea, sweeter than honey to my mouth!
104 Through thy precepts I get understanding:
therefore I hate every false way.

**105 Thy word is a lamp unto my feet, and a
light unto my path.**
106 I have sworn, and I will perform it, that I
will keep thy righteous judgments.

King James Version

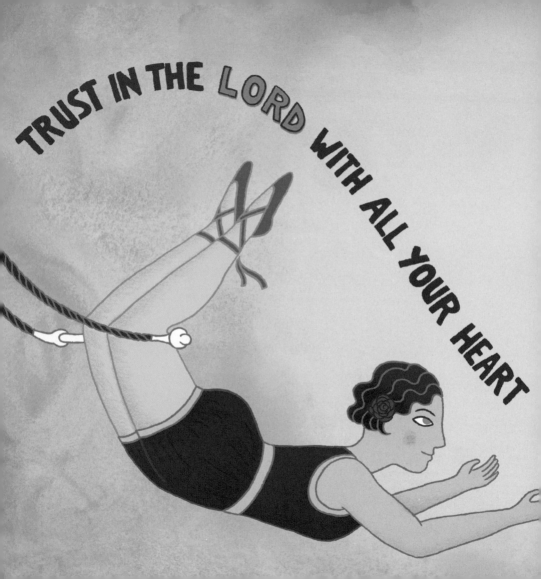

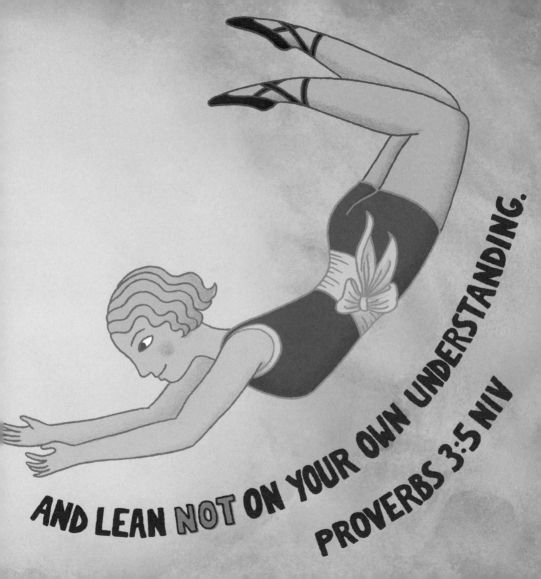

AND LEAN **NOT** ON YOUR OWN UNDERSTANDING.

PROVERBS 3:5 NIV

PROVERBS 4:10–15

10 Listen, my son, and receive my sayings.

The years of your life will be many.

11 I have taught you in the way of wisdom.

I have led you in straight paths.

12 When you go, your steps will not be hampered.

When you run, you will not stumble.

13 Take firm hold of instruction.

Don't let her go.

Keep her, for she is your life.

14 Don't enter into the path of the wicked.

Don't walk in the way of evil men.

15 Avoid it, and don't pass by it.

Turn from it, and pass on.

World English Bible

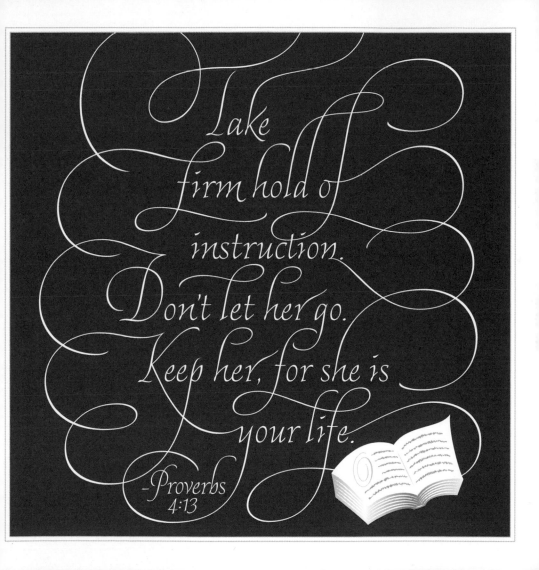

GUARD YOUR HEART
ABOVE ALL ELSE
FOR IT DETERMINES
the course
=OF YOUR LIFE=
—PROVERBS 4:23

20 My child, pay attention to what I say.

Listen carefully to my words.

21 Don't lose sight of them.

Let them penetrate deep into your heart,

22 for they bring life to those who find them,

and healing to their whole body.

23 Guard your heart above all else,

for it determines the course of your life.

New Living Translation

21 For human ways are under the eyes of the LORD,

 and he examines all their paths.

22 The iniquities of the wicked ensnare them,

 and they are caught in the toils of their sin.

23 They die for lack of discipline,

 and because of their great folly they are lost.

New Revised Standard Version

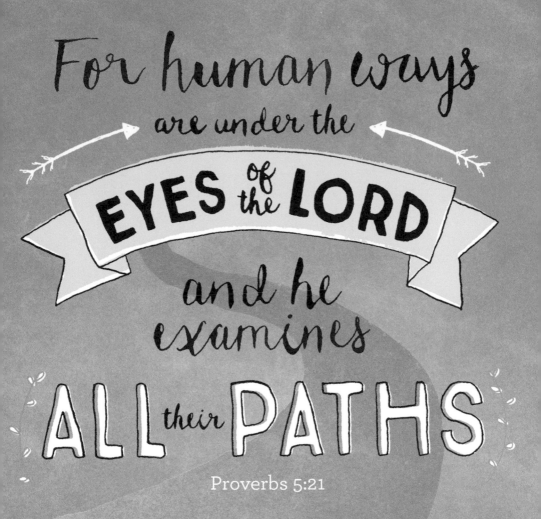

For human ways are under the EYES of the LORD and he examines ALL their PATHS

Proverbs 5:21

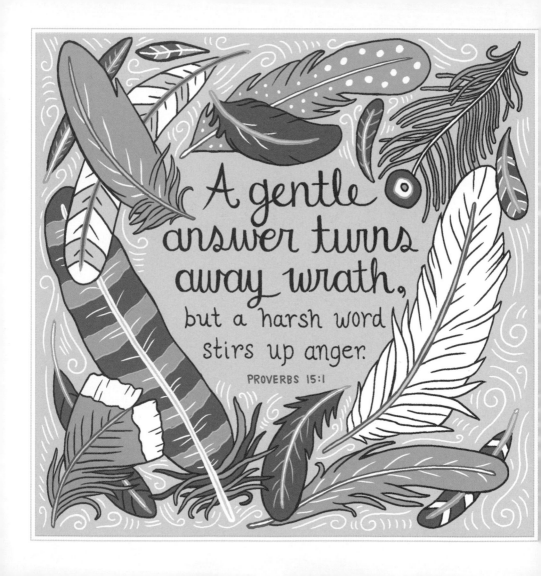

A gentle answer turns away wrath, but a harsh word stirs up anger.

PROVERBS 15:1

1 A gentle answer turns away wrath,
But a harsh word stirs up anger.
2 The tongue of the wise makes knowledge
acceptable,
But the mouth of fools spouts folly.
3 The eyes of the Lord are in every place,
Watching the evil and the good.

New American Standard Bible

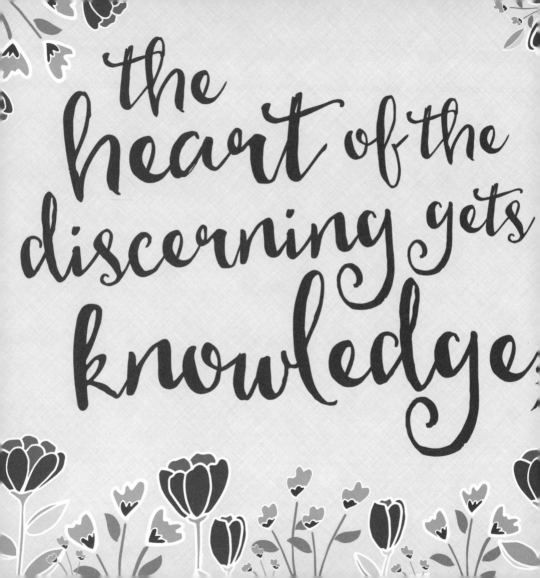

the heart of the discerning gets knowledge

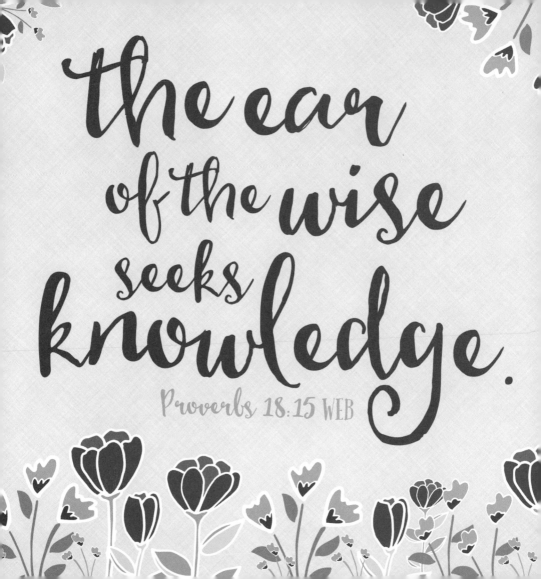

the ear of the wise seeks knowledge.

Proverbs 18:15 WEB

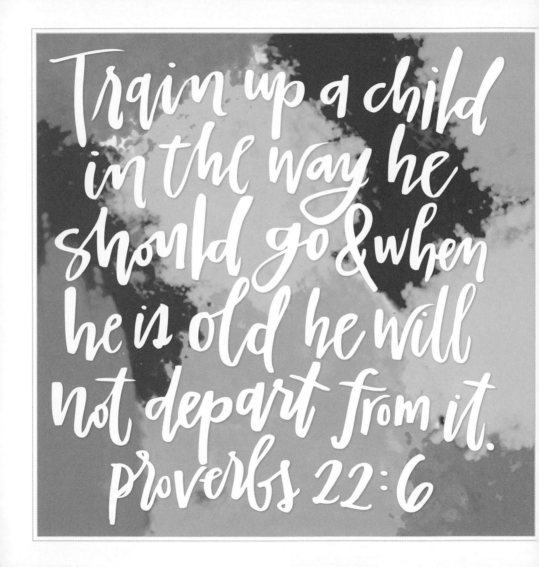

PROVERBS 22:1–6

1 A good name is more desirable than great riches,
 and loving favor is better than silver and gold.

2 The rich and the poor have this in common:
 Yahweh is the maker of them all.

3 A prudent man sees danger, and hides himself;
 but the simple pass on, and suffer for it.

4 The result of humility and the fear of Yahweh
 is wealth, honor, and life.

5 Thorns and snares are in the path of the wicked:
 whoever guards his soul stays from them.

**6 Train up a child in the way he should go,
 and when he is old he will not depart from it.**

World English Bible

17 As iron sharpens iron,

So a man sharpens the countenance of his friend.

18 Whoever keeps the fig tree will eat its fruit;

So he who waits on his master will be honored.

19 As in water face reflects face,

So a man's heart reveals the man.

New King James Version

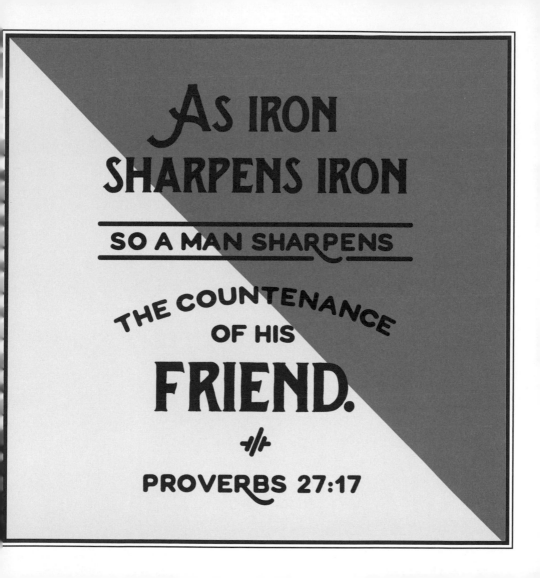

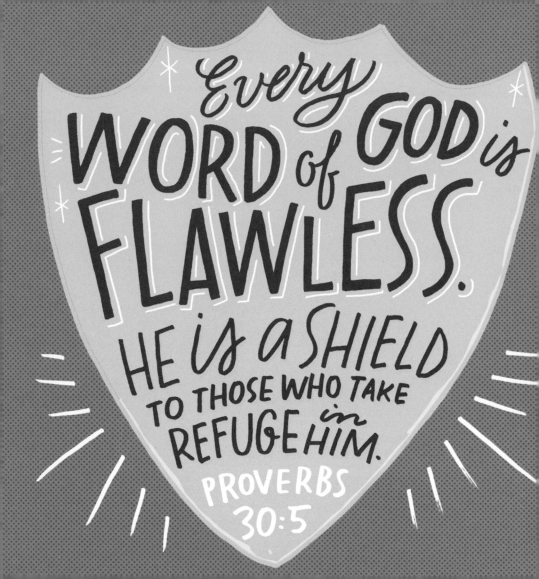

PROVERBS 30:2–6

2 "Surely I am the most ignorant man,

and don't have a man's understanding.

3 I have not learned wisdom,

neither do I have the knowledge of the Holy One.

4 Who has ascended up into heaven, and descended?

Who has gathered the wind in his fists?

Who has bound the waters in his garment?

Who has established all the ends of the earth?

What is his name, and what is his son's name,

if you know?

5 **Every word of God is flawless.**

He is a shield to those who take refuge in him.

6 Don't you add to his words,

lest he reprove you, and you be found a liar."

World English Bible

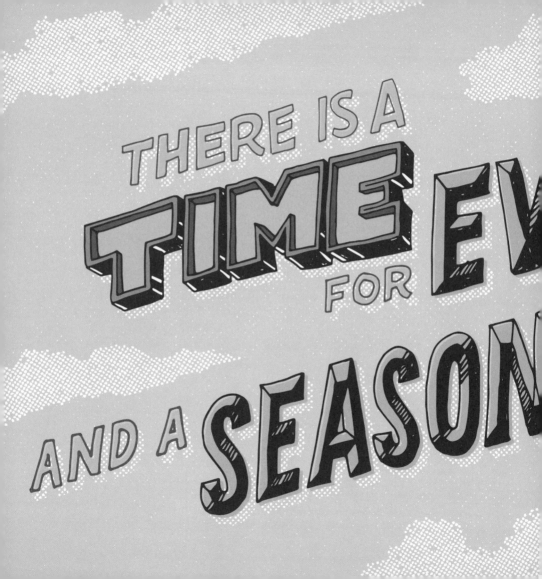

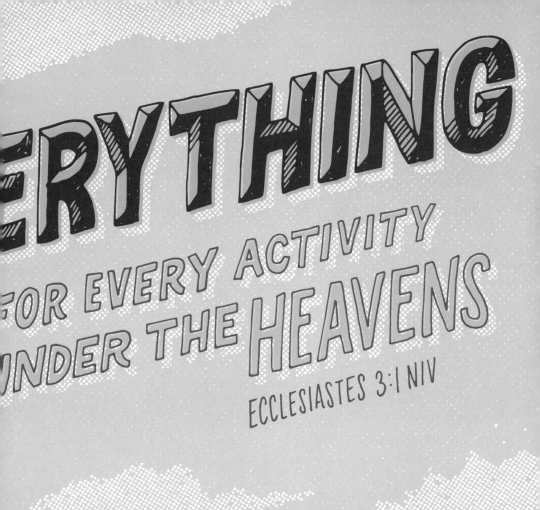

ERYTHING

FOR EVERY ACTIVITY
UNDER THE HEAVENS

ECCLESIASTES 3:1 NIV

ECCLESIASTES 3:10–13

10 I have seen the burden God has placed on us all.

11 Yet God has made everything beautiful for its own
time. **He has planted eternity in the human heart**,
but even so, people cannot see the whole scope of God's
work from beginning to end.

12 So I concluded there is nothing better than to be
happy and enjoy ourselves as long as we can.

13 And people should eat and drink and enjoy the
fruits of their labor, for these are gifts from God.

New Living Translation

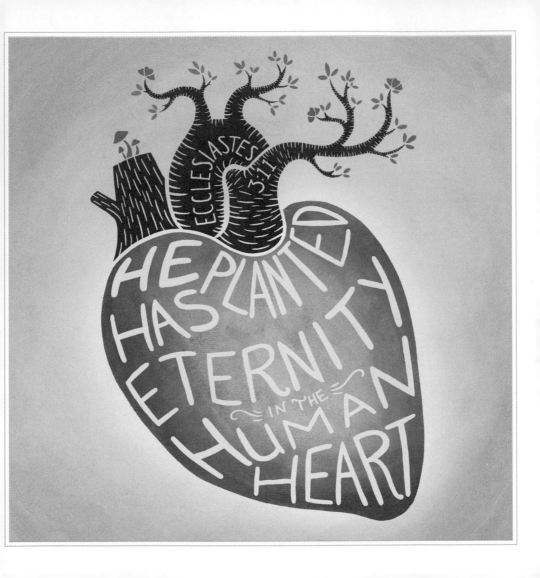

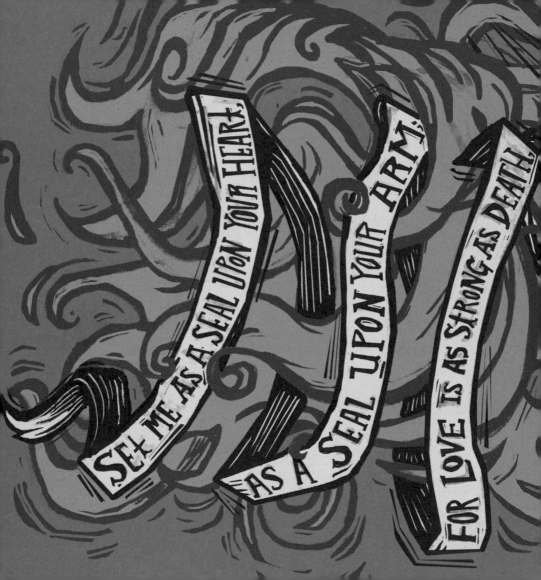

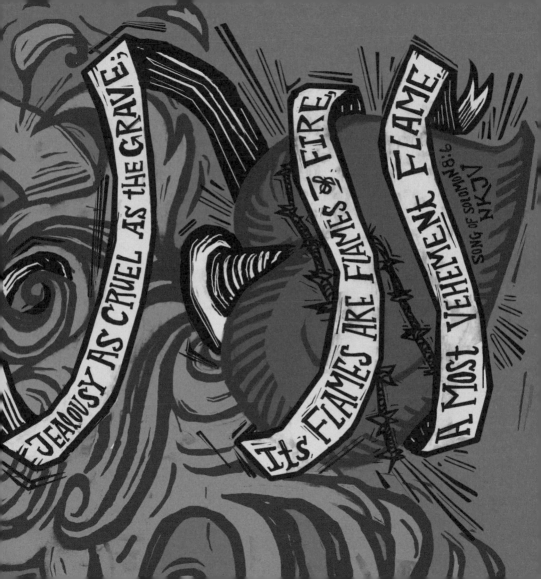

JEALOUSY AS CRUEL AS THE GRAVE; ITS FLAMES ARE FLAMES OF FIRE, A MOST VEHEMENT FLAME.

SONG OF SOLOMON 8:6 NKJV

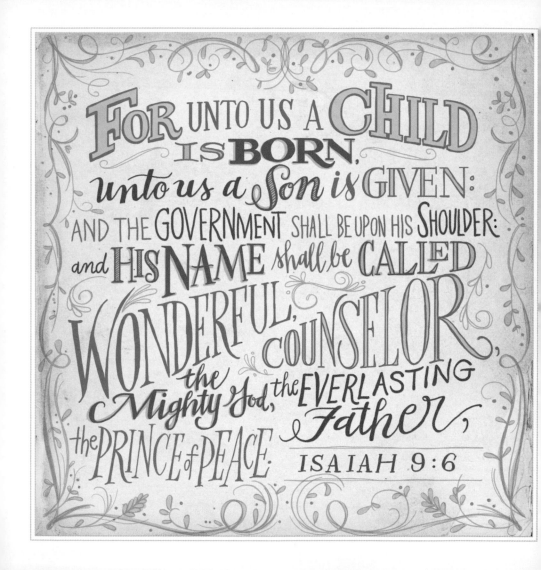

6 For unto us a child is born, unto us a son is given: and the government shall be upon his shoulder: and his name shall be called Wonderful, Counselor, The mighty God, The everlasting Father, The Prince of Peace.

7 Of the increase of his government and peace there shall be no end, upon the throne of David, and upon his kingdom, to order it, and to establish it with judgment and with justice from henceforth even forever. The zeal of the Lord of hosts will perform this.

King James Version

29 Ye shall have a song, as in the night when a holy solemnity is kept; and gladness of heart, as when one goeth with a pipe to come into the mountain of the Lord, to the mighty One of Israel.

30 And the Lord shall cause his glorious voice to be heard, and shall shew the lighting down of his arm, with the indignation of his anger, and with the flame of a devouring fire, with scattering, and tempest, and hailstones.

King James Version

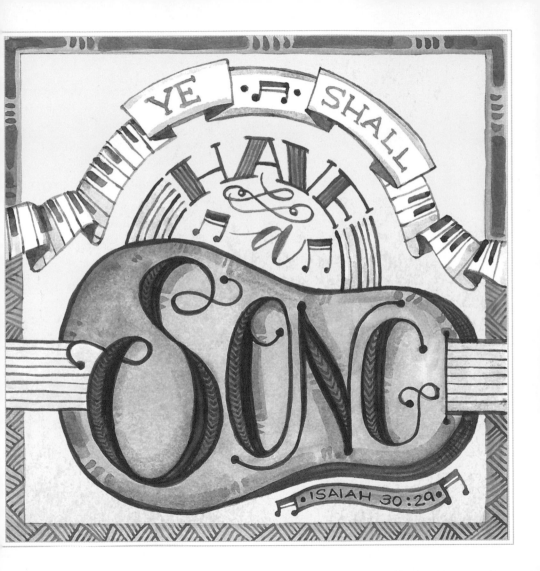

THE FLOWER
FADES

WORD

STANDS

VER

H 40:8 WEB

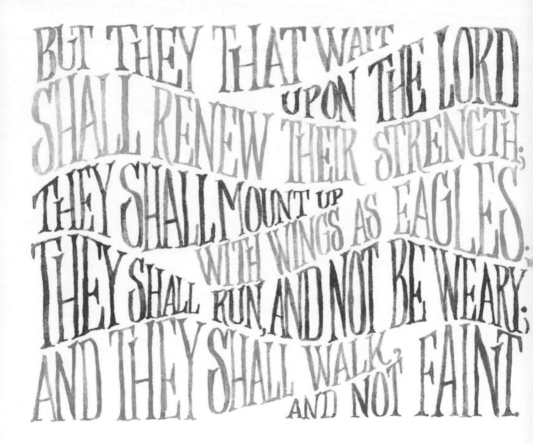

BUT THEY THAT WAIT SHALL RENEW UPON THE LORD THEIR STRENGTH; THEY SHALL MOUNT UP WITH WINGS AS EAGLES, THEY SHALL RUN, AND NOT BE WEARY; AND THEY SHALL WALK, AND NOT FAINT.

ISAIAH 40:31

28 Hast thou not known? hast thou not heard, that the everlasting God, the LORD, the Creator of the ends of the earth, fainteth not, neither is weary? there is no searching of his understanding.

29 He giveth power to the faint; and to them that have no might he increaseth strength.

30 Even the youths shall faint and be weary, and the young men shall utterly fall:

31 But they that wait upon the LORD shall renew their strength; they shall mount up with wings as eagles; they shall run, and not be weary; and they shall walk, and not faint.

King James Version

8 But thou, Israel, art my servant, Jacob whom I
have chosen, the seed of Abraham my friend.
9 Thou whom I have taken from the ends of the
earth, and called thee from the chief men thereof,
and said unto thee, Thou art my servant; I have
chosen thee, and not cast thee away.
10 Fear thou not; for I am with thee: be not
dismayed; for I am thy God: I will strengthen thee;
yea, I will help thee; yea, I will uphold thee with
the right hand of my righteousness.

King James Version

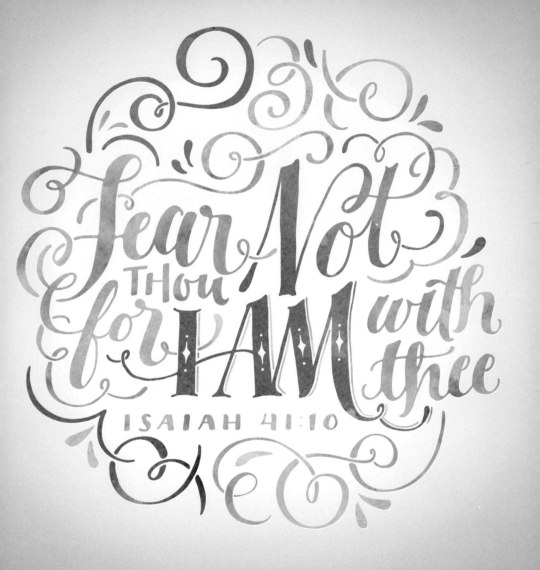

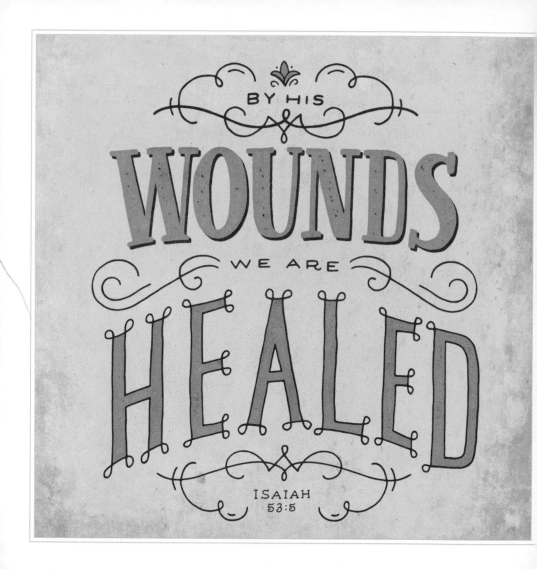

ISAIAH 53:4–6

4 Surely he took up our pain
 and bore our suffering,
 yet we considered him punished by God,
 stricken by him, and afflicted.

5 But he was pierced for our transgressions,
 he was crushed for our iniquities;
 the punishment that brought us peace was on him,
 and **by his wounds we are healed.**

6 We all, like sheep, have gone astray,
 each of us has turned to our own way;
 and the Lᴏʀᴅ has laid on him
 the iniquity of us all.

New International Version

RIT ⟨the⟩ IS UPON ME, HAS ANOINTED ME *news to the poor.* SENT ME TO *brokenhearted.*

ISAIAH 61:1 NLT

6 We all fade like a leaf,

 and our iniquities, like the wind, take us away.

7 There is no one who calls on your name,

 or attempts to take hold of you;

 for you have hidden your face from us,

 and have delivered us into the hand of our iniquity.

8 Yet, O Lord, you are our Father;

 we are the clay, and you are our potter;

 we are all the work of your hand.

New Revised Standard Version

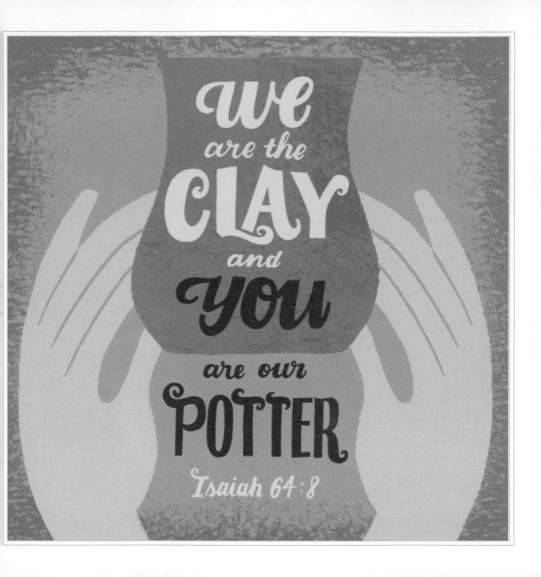

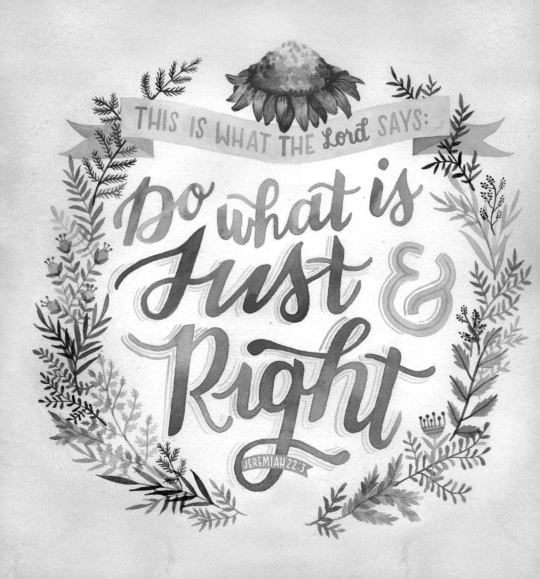

THIS IS WHAT THE Lord SAYS:

Do what is Just & Right

JEREMIAH 22:3

1 This is what the Lᴏʀᴅ says: "Go down to the palace of the king of Judah and proclaim this message there:

2 'Hear the word of the Lᴏʀᴅ to you, king of Judah, you who sit on David's throne—you, your officials and your people who come through these gates.

3 This is what the Lᴏʀᴅ says: Do what is just and right. Rescue from the hand of the oppressor the one who has been robbed. Do no wrong or violence to the foreigner, the fatherless or the widow, and do not shed innocent blood in this place.

4 For if you are careful to carry out these commands, then kings who sit on David's throne will come through the gates of this palace, riding in chariots and on horses, accompanied by their officials and their people.

5 But if you do not obey these commands, declares the Lᴏʀᴅ, I swear by myself that this palace will become a ruin.'"

New International Version

JEREMIAH 29:10–12

10 This is what the LORD says: "When seventy years are completed for Babylon, I will come to you and fulfill my good promise to bring you back to this place.

11 For I know the plans I have for you," declares the LORD, "plans to prosper you and not to harm you, plans to give you hope and a future.

12 Then you will call on me and come and pray to me, and I will listen to you."

New International Version

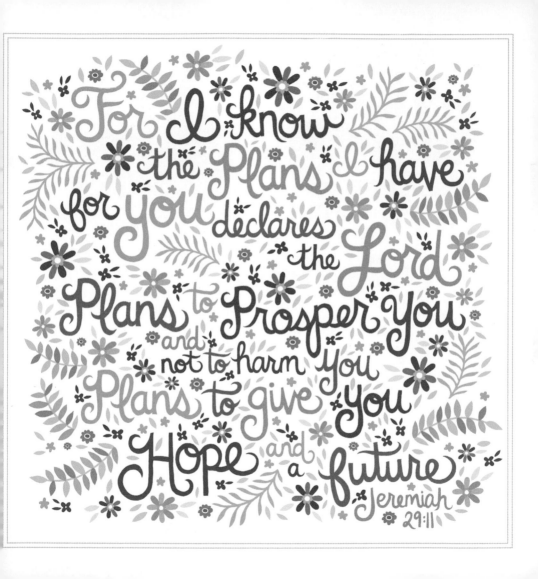

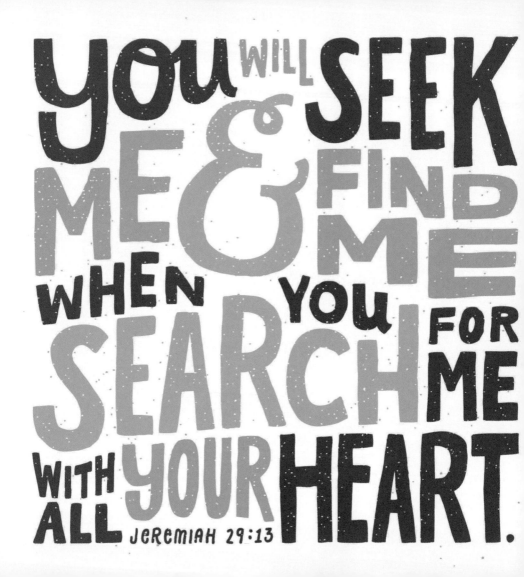

13 You will seek Me and find Me when you search for Me with all your heart.

14 "I will be found by you," declares the Lord, "and I will restore your fortunes and will gather you from all the nations and from all the places where I have driven you," declares the Lord, "and I will bring you back to the place from where I sent you into exile."

New American Standard Bible

1 Then the word of the LORD came to Jeremiah the second time, while he was still confined in the court of the guard, saying,

2 "Thus says the LORD who made the earth, the LORD who formed it to establish it, the LORD is His name,

3 'Call to Me and I will answer you, and I will tell you great and mighty things, which you do not know.'"

New American Standard Bible

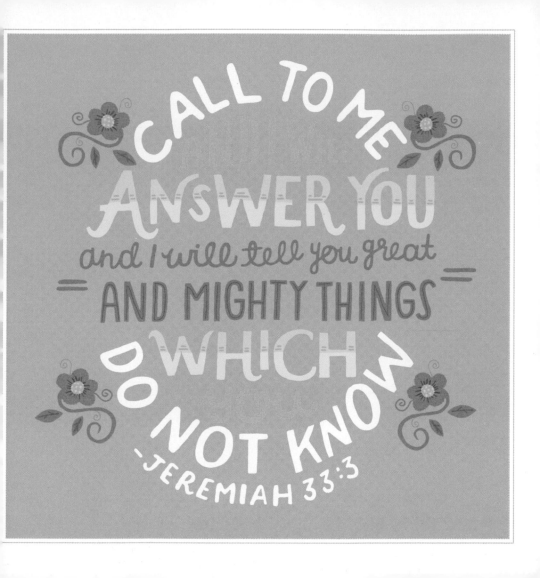

It will HAPPEN afterward, that I will pour out my SPIRIT on all FLESH; And your sons and your DaughTERS will PROPHESY.

your old men will dream DREAMS. your YOUNG men will SEE visions.

Joel 2:28 WEB

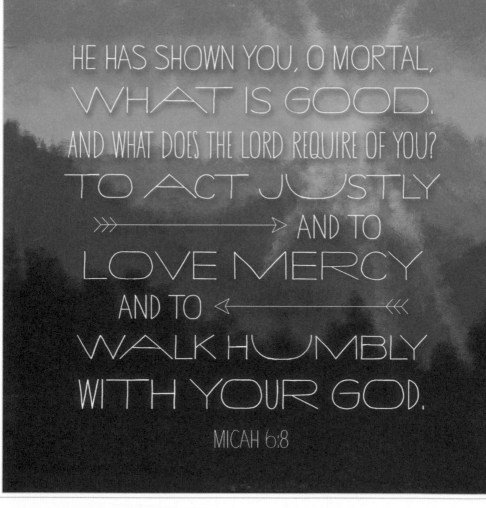

HE HAS SHOWN YOU, O MORTAL,
WHAT IS GOOD.
AND WHAT DOES THE LORD REQUIRE OF YOU?
TO ACT JUSTLY
>>>————————> AND TO
LOVE MERCY
AND TO <————————<<<
WALK HUMBLY
WITH YOUR GOD.

MICAH 6:8

MICAH 6:6–8

6 With what shall I come before the Lord
 and bow down before the exalted God?
 Shall I come before him with burnt offerings,
 with calves a year old?

7 Will the Lord be pleased with thousands of rams,
 with ten thousand rivers of olive oil?
 Shall I offer my firstborn for my transgression,
 the fruit of my body for the sin of my soul?

8 He has shown you, O mortal, what is good.
 And what does the LORD require of you?
 To act justly and to love mercy
 and to walk humbly with your God.

New International Version

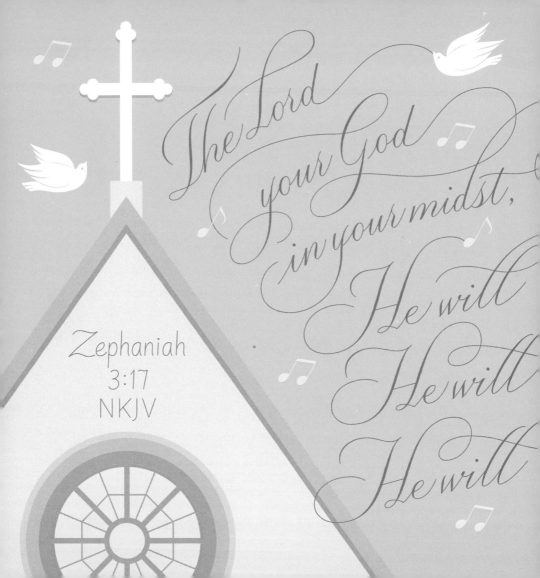

The Lord your God in your midst, He will He will He will

Zephaniah 3:17 NKJV

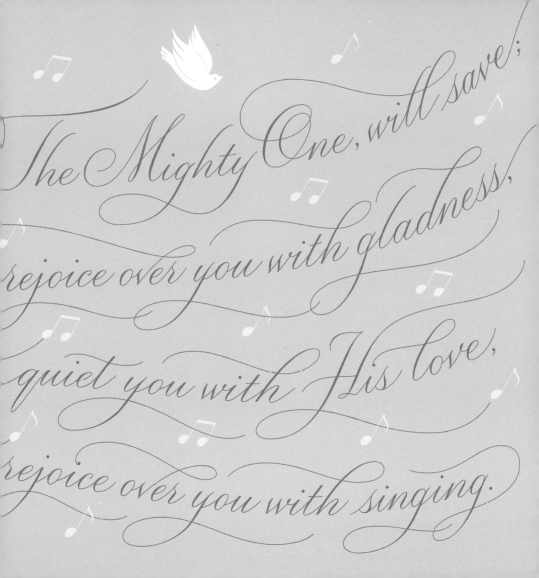

The Mighty One, will save;
rejoice over you with gladness,
quiet you with His love,
rejoice over you with singing.

New Testament

13 "You are the salt of the earth; but if salt has lost its taste, how can its saltiness be restored? It is no longer good for anything, but is thrown out and trampled under foot.

14 You are the light of the world. A city built on a hill cannot be hid.

15 No one after lighting a lamp puts it under the bushel basket, but on the lampstand, and it gives light to all in the house.

16 In the same way, **let your light shine before others**, so that they may see your good works and give glory to your Father in heaven."

New Revised Standard Version

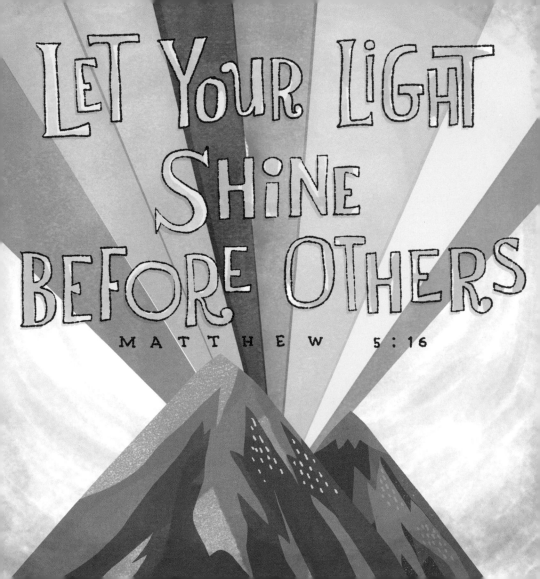

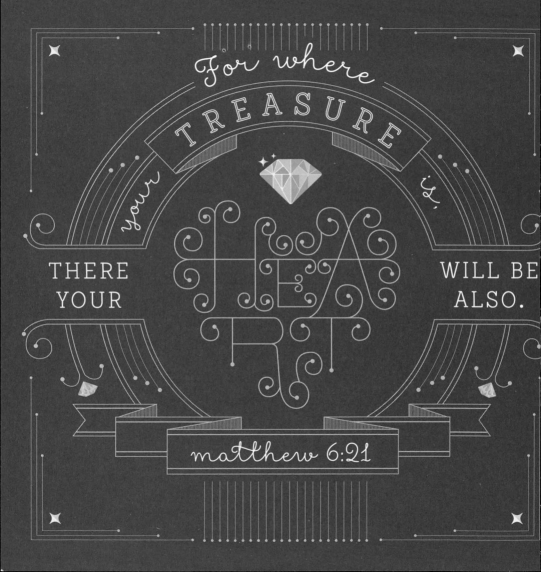

19 "Don't lay up treasures for yourselves on the earth, where moth and rust consume, and where thieves break through and steal;

20 but lay up for yourselves treasures in heaven, where neither moth nor rust consume, and where thieves don't break through and steal;

21 for where your treasure is, there your heart will be also."

World English Bible

31 "So don't worry about these things, saying, 'What will we eat? What will we drink? What will we wear?'

32 These things dominate the thoughts of unbelievers, but your heavenly Father already knows all your needs.

33 Seek the Kingdom of God above all else, and live righteously, and he will give you everything you need.

34 So **don't worry about tomorrow, for tomorrow will bring its own worries.** Today's trouble is enough for today."

New Living Translation

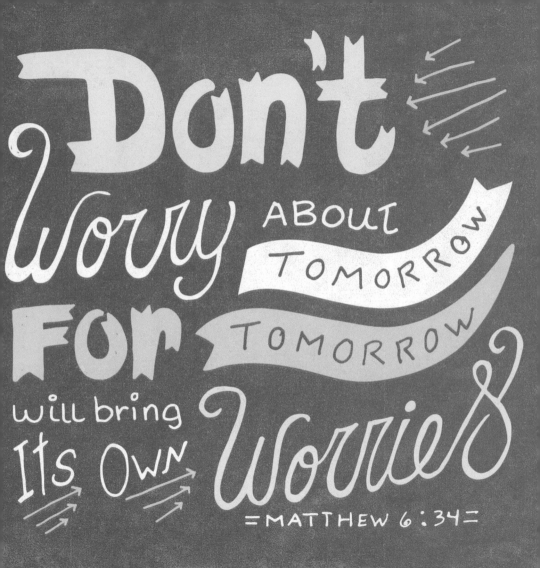

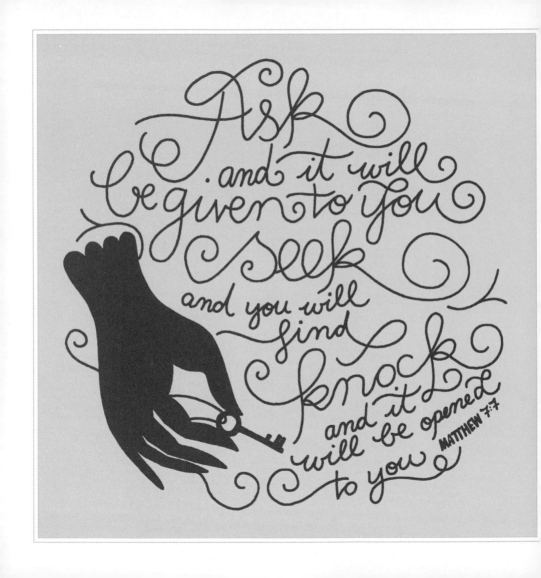

7 Ask, and it will be given to you; seek, and you will find; knock, and it will be opened to you.

8 For everyone who asks receives, and he who seeks finds, and to him who knocks it will be opened.

New American Standard Bible

WHAT IS THE PRICE of TWO SPARROWS— ONE COPPER COIN?

MATTHEW 10:29 NLT

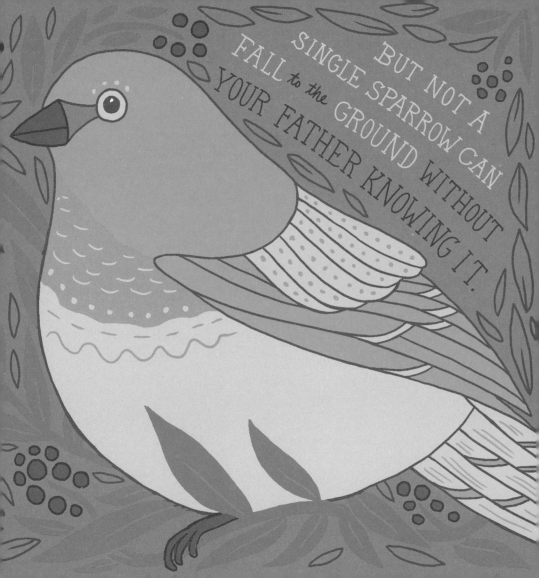

BUT NOT A SINGLE SPARROW CAN FALL to the GROUND WITHOUT YOUR FATHER KNOWING IT.

18 Jesus rebuked him, the demon went out of him,
and the boy was cured from that hour.
19 Then the disciples came to Jesus privately, and
said, "Why weren't we able to cast it out?"
20 He said to them, "Because of your unbelief. For
most certainly I tell you, **if you have faith as a grain
of mustard seed, you will tell this mountain, 'Move
from here to there,' and it will move; and nothing
will be impossible for you.**
21 But this kind doesn't go out except by prayer
and fasting."

World English Bible

IF YOU HAVE FAITH AS A GRAIN OF MUSTARD SEED, YOU WILL TELL THIS MOUNTAIN, 'MOVE FROM HERE TO THERE,' AND IT WILL MOVE;

AND NOTHING WILL BE IMPOSSIBLE FOR YOU.

MATTHEW 17:20

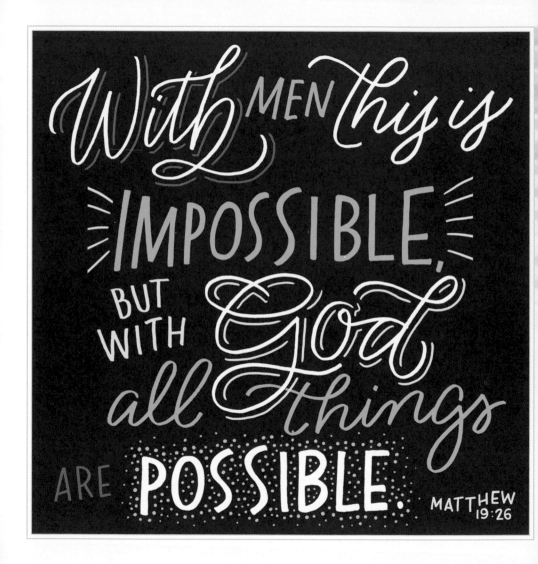

With MEN This is IMPOSSIBLE, BUT WITH God all things ARE POSSIBLE.

MATTHEW 19:26

23 Jesus said to his disciples, "Most certainly I say to you, a rich man will enter into the Kingdom of Heaven with difficulty.

24 Again I tell you, it is easier for a camel to go through a needle's eye, than for a rich man to enter into God's Kingdom."

25 When the disciples heard it, they were exceedingly astonished, saying, "Who then can be saved?"

26 Looking at them, Jesus said, **"With men this is impossible, but with God all things are possible."**

World English Bible

"'LOVE THE LORD YOUR GOD WITH ALL YOUR HEART AND WITH ALL YOUR SOUL AND WITH ALL YOUR MIND.' THIS IS THE FIRST AND GREATEST COMMANDMENT.

AND THE SECOND IS LIKE IT:

'LOVE YOUR NEIGHBOR AS YOURSELF.'"

MATTHEW 22:37-39 NIV

16 Now the eleven disciples went to Galilee, to the mountain to which Jesus had directed them.

17 When they saw him, they worshipped him; but some doubted.

18 And Jesus came and said to them, "All authority in heaven and on earth has been given to me.

19 **Go therefore and make disciples of all nations**, baptizing them in the name of the Father and of the Son and of the Holy Spirit,

20 and teaching them to obey everything that I have commanded you. And remember, I am with you always, to the end of the age."

New Revised Standard Version

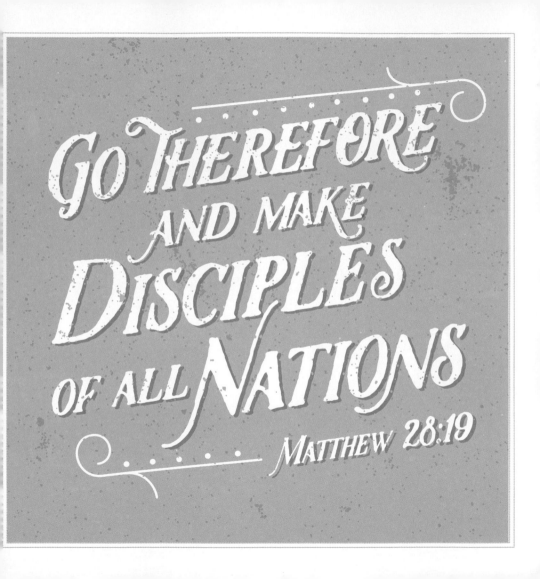

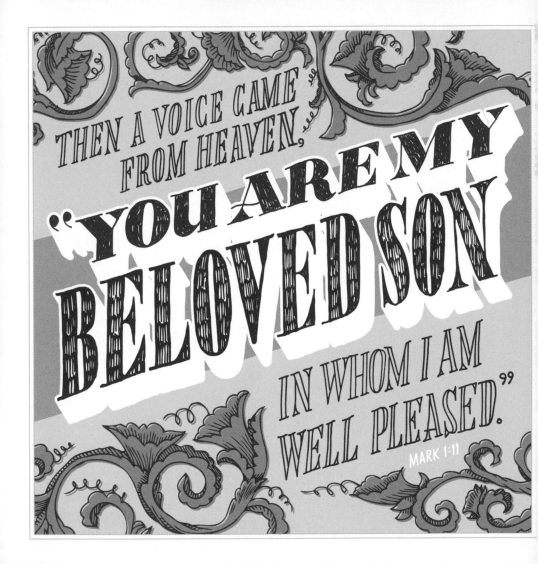

THEN A VOICE CAME FROM HEAVEN, "YOU ARE MY BELOVED SON IN WHOM I AM WELL PLEASED."

MARK 1:11

9 It came to pass in those days that Jesus came from Nazareth of Galilee, and was baptized by John in the Jordan.

10 And immediately, coming up from the water, He saw the heavens parting and the Spirit descending upon Him like a dove.

11 Then a voice came from heaven, "You are My beloved Son, in whom I am well pleased."

12 Immediately the Spirit drove Him into the wilderness.

13 And He was there in the wilderness forty days, tempted by Satan, and was with the wild beasts; and the angels ministered to Him.

New King James Version

8 And there were shepherds living out in the fields nearby, keeping watch over their flocks at night.

9 An angel of the Lord appeared to them, and the glory of the Lord shone around them, and they were terrified.

10 But the angel said to them, "Do not be afraid. I bring you good news that will cause great joy for all the people.

11 Today in the town of David a Savior has been born to you; he is the Messiah, the Lord.

12 This will be a sign to you: You will find a baby wrapped in cloths and lying in a manger."

13 Suddenly a great company of the heavenly host appeared with the angel, praising God and saying,

14 "Glory to God in the highest heaven, and on earth peace to those on whom his favor rests."

15 When the angels had left them and gone into heaven, the shepherds said to one another, "Let's go to Bethlehem and see this thing that has happened, which the Lord has told us about."

New International Version

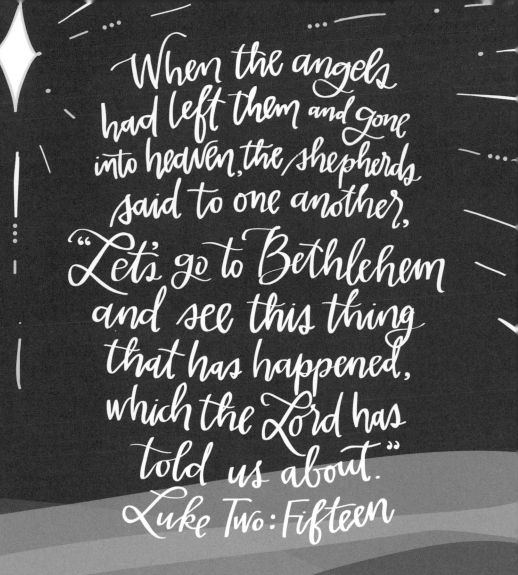

When the angels had left them and gone into heaven, the shepherds said to one another, "Let's go to Bethlehem and see this thing that has happened, which the Lord has told us about."

Luke Two: Fifteen

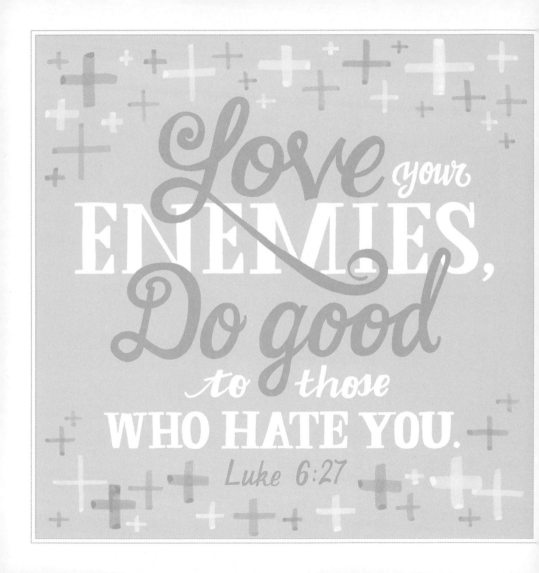

Love your ENEMIES, Do good to those WHO HATE YOU.

Luke 6:27

27 "But I say to you that listen, **Love your enemies, do good to those who hate you,**

28 bless those who curse you, pray for those who abuse you.

29 If anyone strikes you on the cheek, offer the other also; and from anyone who takes away your coat do not withhold even your shirt.

30 Give to everyone who begs from you; and if anyone takes away your goods, do not ask for them again.

31 Do to others as you would have them do to you.

32 If you love those who love you, what credit is that to you? For even sinners love those who love them.

33 If you do good to those who do good to you, what credit is that to you? For even sinners do the same.

34 If you lend to those from whom you hope to receive, what credit is that to you? Even sinners lend to sinners, to receive as much again.

35 But love your enemies, do good, and lend, expecting nothing in return. Your reward will be great, and you will be children of the Most High; for he is kind to the ungrateful and the wicked."

36 Be merciful, just as your Father is merciful.

New Revised Standard Version

20 And He said to them, "But who do you say that I am?" And Peter answered and said, "The Christ of God."

21 But He warned them and instructed them not to tell this to anyone,

22 saying, "The Son of Man must suffer many things and be rejected by the elders and chief priests and scribes, and be killed and be raised up on the third day."

23 And He was saying to them all, **"If anyone wishes to come after Me, he must deny himself, and take up his cross daily and follow Me."**

24 For whoever wishes to save his life will lose it, but whoever loses his life for My sake, he is the one who will save it.

New American Standard Bible

If ANYONE WISHES TO COME after ME, HE MUST DENY HIMSELF, and TAKE UP HIS CROSS DAILY AND FOLLOW ME.

LUKE 9:23

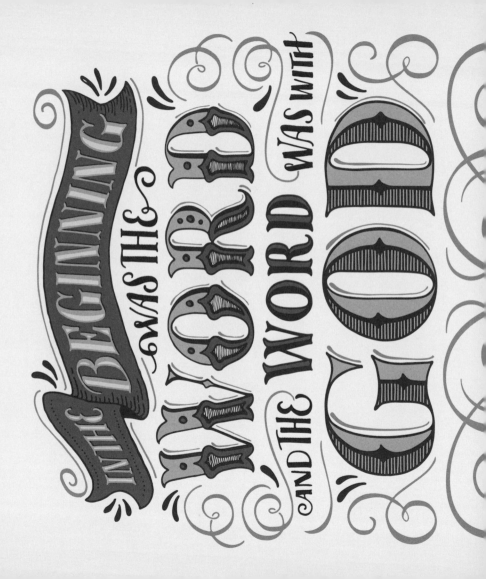

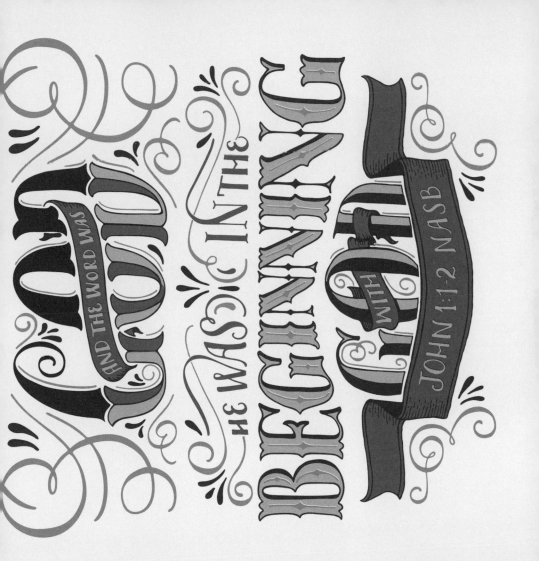

GOD

AND THE WORD WAS

IN THE

HE WAS

BEGINNING

WITH

GOD

JOHN 1:1-2 NASB

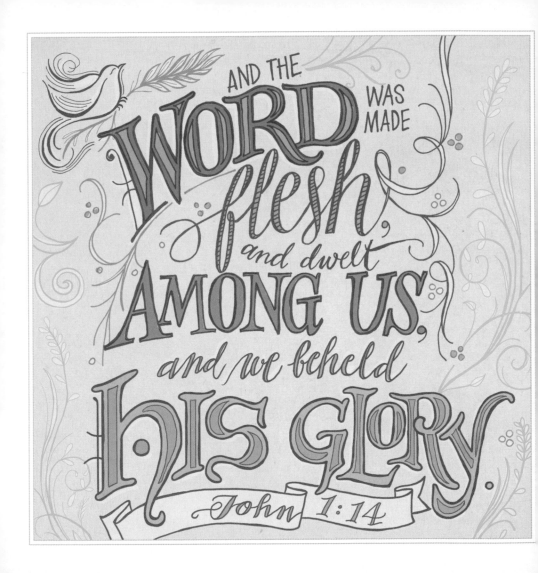

AND THE WORD WAS MADE *flesh*, and dwelt AMONG US, and we beheld his glory.

John 1:14

11 He came unto his own, and his own received him not.

12 But as many as received him, to them gave he power to become the sons of God, even to them that believe on his name:

13 Which were born, not of blood, nor of the will of the flesh, nor of the will of man, but of God.

14 And the Word was made flesh, and dwelt among us, (and we beheld his glory, the glory as of the only begotten of the Father,) full of grace and truth.

King James Version

16 For God so loved the world that He gave His only begotten Son, that whoever believes in Him should not perish but have everlasting life.

17 For God did not send His Son into the world to condemn the world, but that the world through Him might be saved.

18 He who believes in Him is not condemned; but he who does not believe is condemned already, because he has not believed in the name of the only begotten Son of God.

19 And this is the condemnation, that the light has come into the world, and men loved darkness rather than light, because their deeds were evil.

20 For everyone practicing evil hates the light and does not come to the light, lest his deeds should be exposed.

21 But he who does the truth comes to the light, that his deeds may be clearly seen, that they have been done in God.

New King James Version

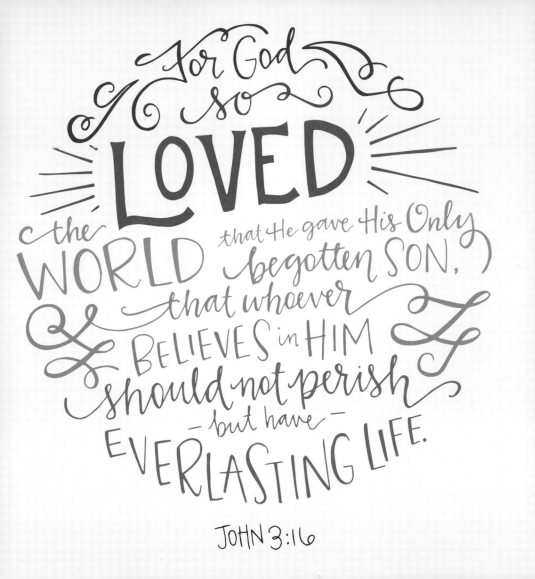

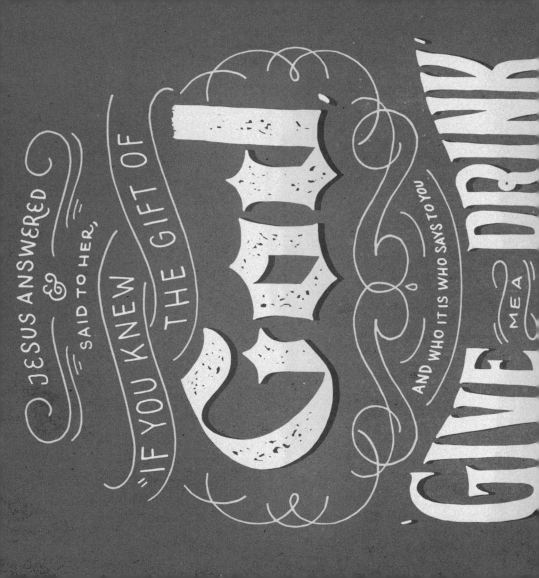

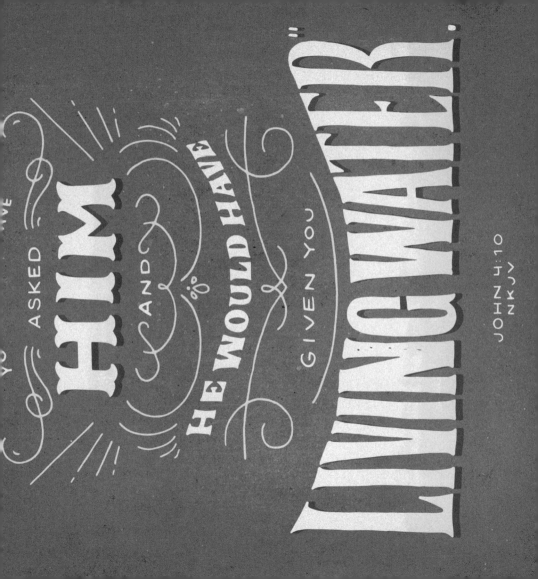

YOU ... ASKED HIM AND HE WOULD HAVE GIVEN YOU LIVING WATER

JOHN 4:10
NKJV

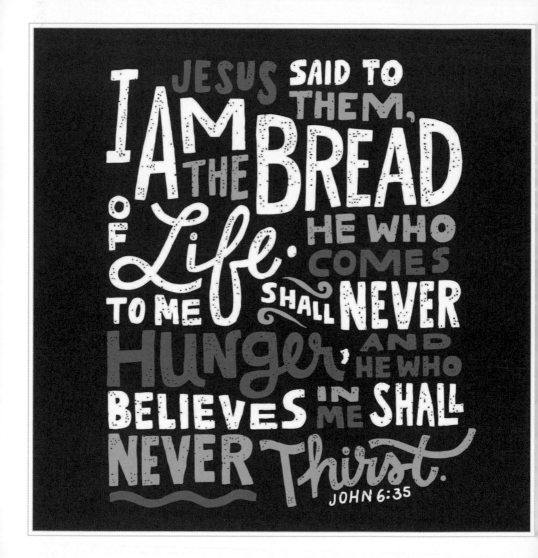

32 Then Jesus said to them, "Most assuredly, I say to you, Moses did not give you the bread from heaven, but My Father gives you the true bread from heaven.

33 For the bread of God is He who comes down from heaven and gives life to the world."

34 Then they said to Him, "LORD, give us this bread always."

35 And **Jesus said to them, "I am the bread of life. He who comes to Me shall never hunger, and he who believes in Me shall never thirst.**

36 But I said to you that you have seen Me and yet do not believe.

37 All that the Father gives Me will come to Me, and the one who comes to Me I will by no means cast out.

38 For I have come down from heaven, not to do My own will, but the will of Him who sent Me.

39 This is the will of the Father who sent Me, that of all He has given Me I should lose nothing, but should raise it up at the last day.

40 And this is the will of Him who sent Me, that everyone who sees the Son and believes in Him may have everlasting life; and I will raise him up at the last day."

New King James Version

24 Martha said to Him, "I know that he will rise again in the resurrection at the last day."

25 Jesus said to her, **"I am the resurrection and the life. He who believes in Me, though he may die, he shall live.**

26 And whoever lives and believes in Me shall never die. Do you believe this?"

27 She said to Him, "Yes, Lord, I believe that You are the Christ, the Son of God, who is to come into the world."

New King James Version

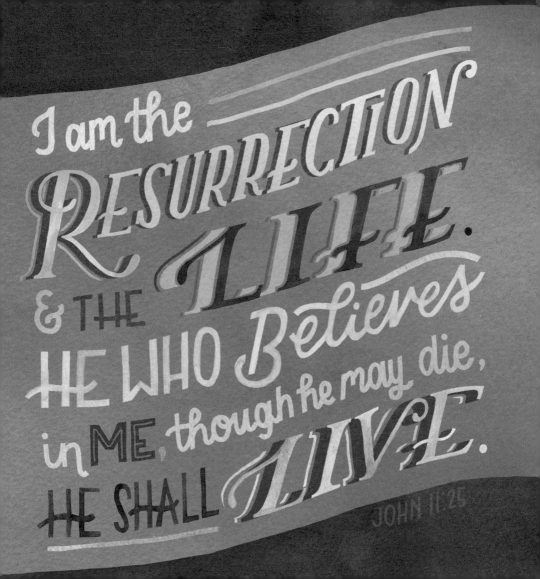

I am the
way, and the
truth, and the life;
no one comes
to the Father
but through
me.

John 14:6

1 "Do not let your heart be troubled; believe in God, believe also in Me.

2 In My Father's house are many dwelling places; if it were not so, I would have told you; for I go to prepare a place for you.

3 If I go and prepare a place for you, I will come again and receive you to Myself, that where I am, there you may be also.

4 And you know the way where I am going."

5 Thomas said to Him, "Lord, we do not know where You are going, how do we know the way?"

6 Jesus said to him, **"I am the way, and the truth, and the life; no one comes to the Father but through Me."**

New American Standard Bible

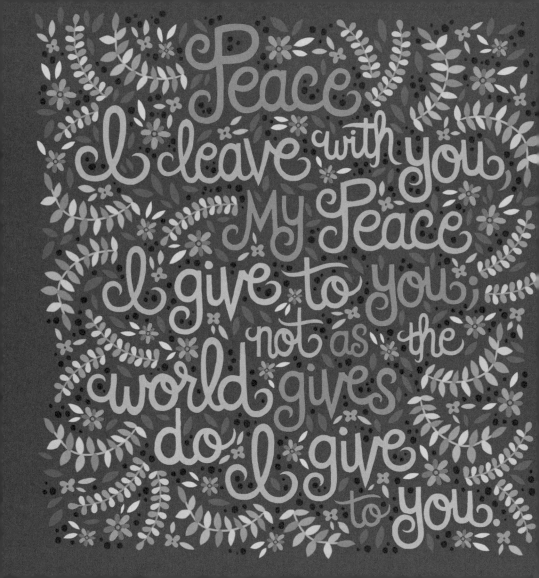

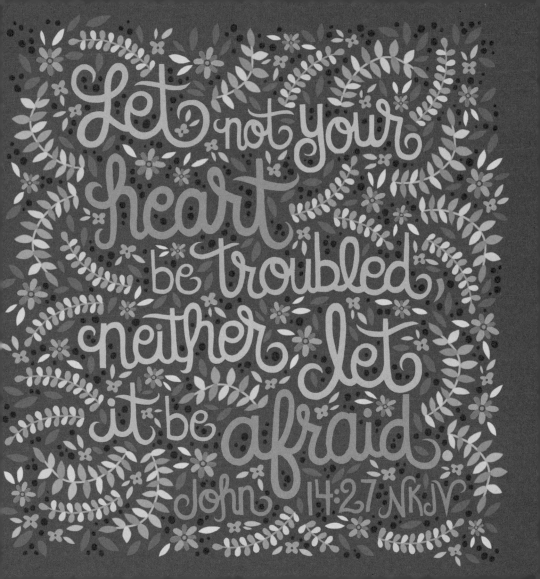

1 I am the true vine, and my Father is the farmer.

2 Every branch in me that doesn't bear fruit, he takes away. Every branch that bears fruit, he prunes, that it may bear more fruit.

3 You are already pruned clean because of the word which I have spoken to you.

4 Remain in me, and I in you. As the branch can't bear fruit by itself, unless it remains in the vine, so neither can you, unless you remain in me.

5 I am the vine. You are the branches. He who remains in me, and I in him, the same bears much fruit, for apart from me you can do nothing.

World English Bible

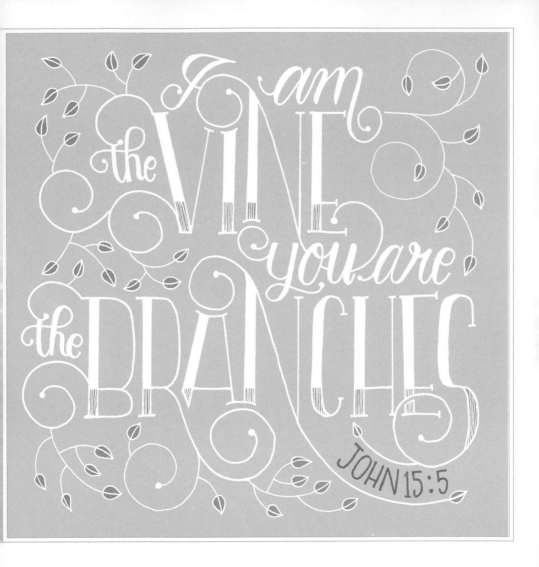

I am the VINE you are the BRANCHES

JOHN 15:5

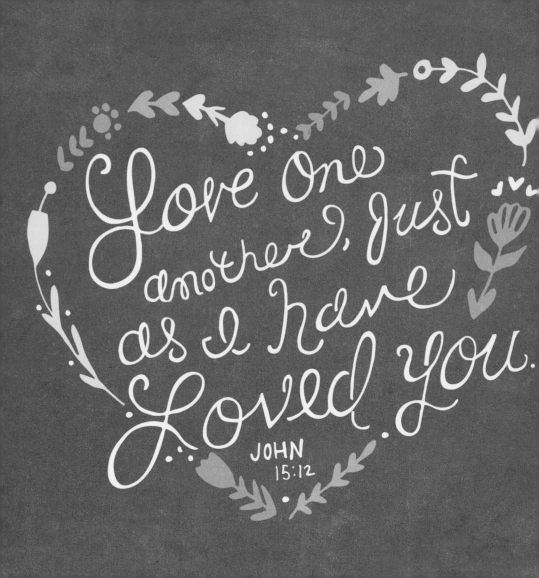

Love one another, just as I have loved you.

JOHN
15:12

10 "If you keep My commandments, you will abide in My love; just as I have kept My Father's commandments and abide in His love.

11 These things I have spoken to you so that My joy may be in you, and that your joy may be made full.

12 This is My commandment, that you **love one another, just as I have loved you.**

13 Greater love has no one than this, that one lay down his life for his friends."

New American Standard Bible

31 "Do you now believe?" Jesus replied.

32 "A time is coming and in fact has come when you will be scattered, each to your own home. You will leave me all alone. Yet I am not alone, for my Father is with me.

33 I have told you these things, so that in me you may have peace. **In this world you will have trouble. But take heart! I have overcome the world."**

New International Version

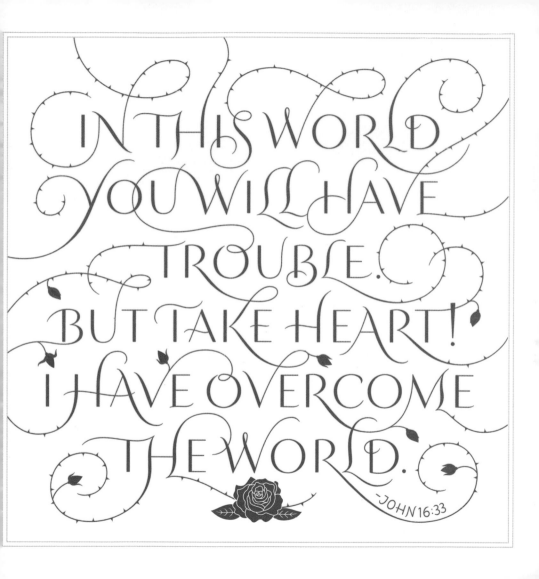

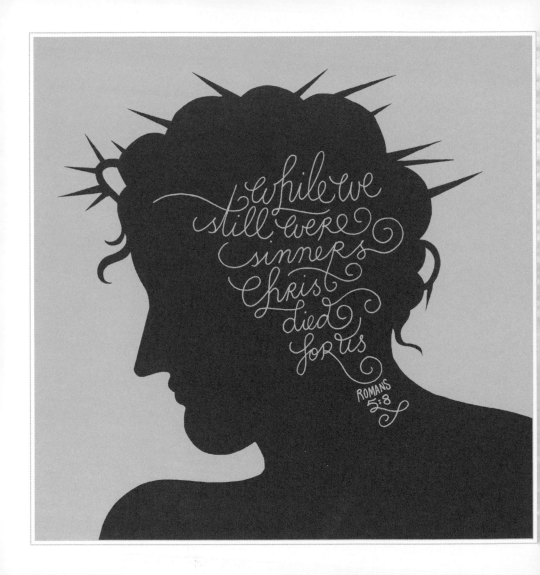

8 But God proves his love for us in that **while we still were sinners Christ died for us.**

9 Much more surely then, now that we have been justified by his blood, will we be saved through him from the wrath of God.

10 For if while we were enemies, we were reconciled to God through the death of his Son, much more surely, having been reconciled, will we be saved by his life.

11 But more than that, we even boast in God through our Lord Jesus Christ, through whom we have now received reconciliation.

New Revised Standard Version

And we know
God works for
who have
according to

that in all things
those who love him,
been called
his purpose.

Romans 8:28 NIV

1 I appeal to you therefore, brothers and sisters, by the mercies of God, to present your bodies as a living sacrifice, holy and acceptable to God, which is your spiritual worship.

2 Do not be conformed to this world, but be transformed by the renewing of your minds, so that you may discern what is the will of God— what is good and acceptable and perfect.

New Revised Standard Version

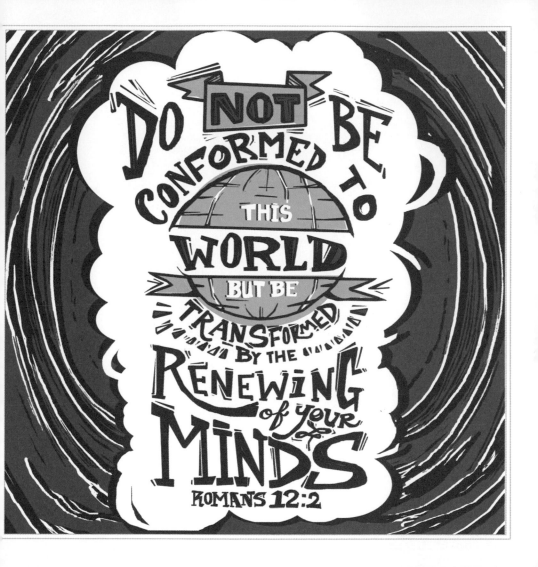

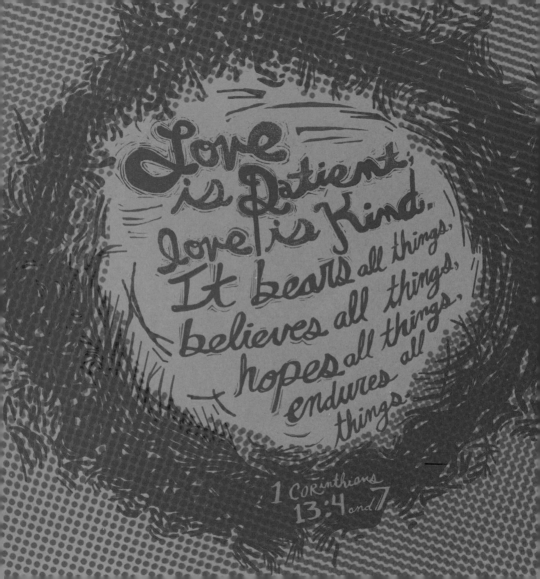

Love is Patient; love is Kind. It bears all things, believes all things, hopes all things, endures all things.

1 Corinthians 13:4 and 7

I CORINTHIANS 13:1–8

1 If I speak in the tongues of mortals and of angels, but do not have love, I am a noisy gong or a clanging cymbal.

2 And if I have prophetic powers, and understand all mysteries and all knowledge, and if I have all faith, so as to remove mountains, but do not have love, I am nothing.

3 If I give away all my possessions, and if I hand over my body so that I may boast, but do not have love, I gain nothing.

4 **Love is patient; love is kind;** love is not envious or boastful or arrogant

5 or rude. It does not insist on its own way; it is not irritable or resentful;

6 it does not rejoice in wrongdoing, but rejoices in the truth.

7 **It bears all things, believes all things, hopes all things, endures all things.**

8 Love never ends. But as for prophecies, they will come to an end; as for tongues, they will cease; as for knowledge, it will come to an end.

New Revised Standard Version

13 Be on your guard; stand firm in the faith;

be courageous; be strong.

14 Do everything in love.

New International Version

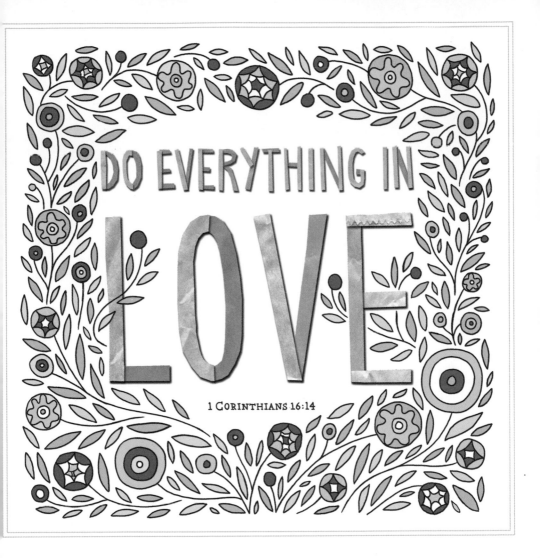

DO EVERYTHING IN LOVE

1 CORINTHIANS 16:14

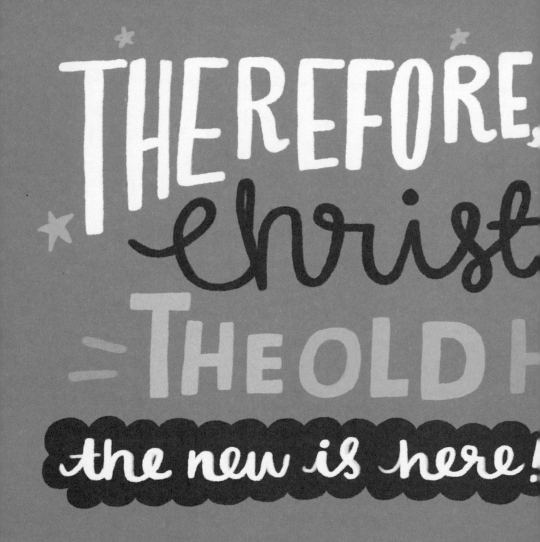

THEREFORE, christ

THE OLD H

the new is here!

F ANYONE IS IN

THE NEW CREATION HAS COME:

AS GONE,

— II CORINTHIANS 5:17 NIV

HE HAS SAID TO ME, "MY GRACE IS SUFFICIENT FOR YOU, FOR MY POWER IS MADE PERFECT IN WEAKNESS." MOST GLADLY THEREFORE I WILL RATHER GLORY IN MY WEAKNESSES, THAT THE POWER OF CHRIST MAY REST ON ME.

II CORINTHIANS 12:9

9 He has said to me, "My grace is sufficient for you, for my power is made perfect in weakness." Most gladly therefore I will rather glory in my weaknesses, that the power of Christ may rest on me.

10 Therefore I take pleasure in weaknesses, in injuries, in necessities, in persecutions, in distresses, for Christ's sake. For when I am weak, then am I strong.

World English Bible

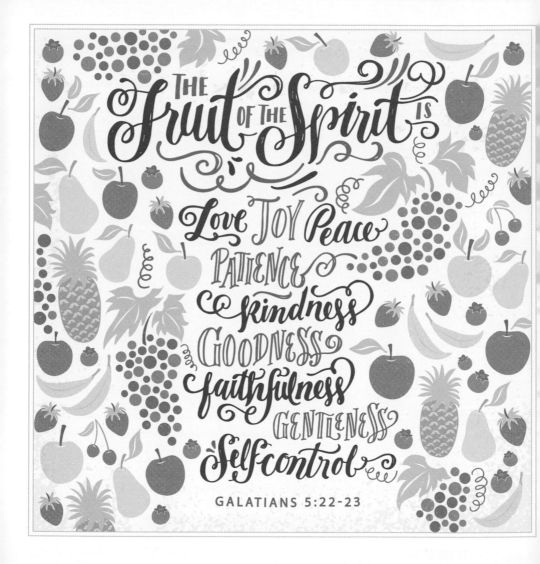

The Fruit of the Spirit is

Love Joy Peace
Patience
kindness
Goodness
faithfulness
Gentleness
Self-control

GALATIANS 5:22-23

22 But **the fruit of the Spirit is love, joy, peace, patience, kindness, goodness, faithfulness, 23 gentleness, self-control**; against such things there is no law.

24 Now those who belong to Christ Jesus have crucified the flesh with its passions and desires.

25 If we live by the Spirit, let us also walk by the Spirit.

New American Standard Bible

8 For it is by grace you have been saved, through faith—and this is not from yourselves, it is the gift of God—

9 not by works, so that no one can boast.

10 For we are God's handiwork, created in Christ Jesus to do good works, which God prepared in advance for us to do.

New International Version

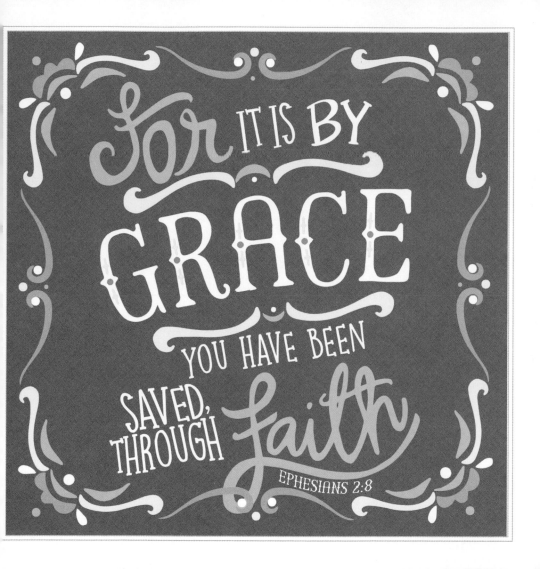

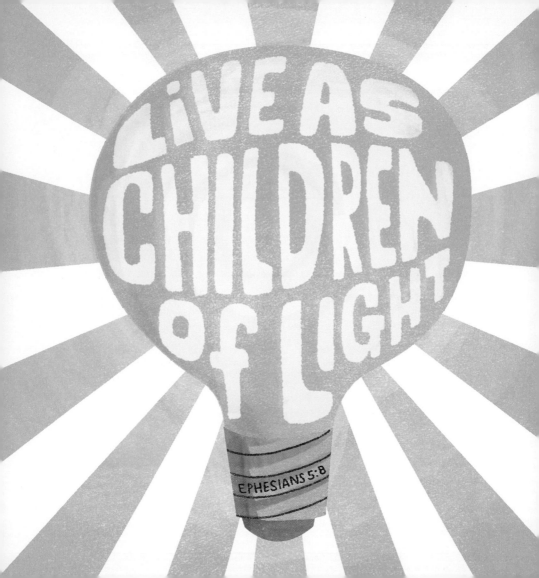

6 Let no one deceive you with empty words, for because of these things the wrath of God comes on those who are disobedient.

7 Therefore do not be associated with them.

8 For once you were darkness, but now in the Lord you are light. **Live as children of light—**

9 for the fruit of the light is found in all that is good and right and true.

10 Try to find out what is pleasing to the Lord.

11 Take no part in the unfruitful works of darkness, but instead expose them.

12 For it is shameful even to mention what such people do secretly;

13 but everything exposed by the light becomes visible,

14 for everything that becomes visible is light.

New Revised Standard Version

4 Rejoice in the LORD always. I will say it again:
Rejoice!

5 Let your gentleness be evident to all. The LORD
is near.

**6 Do not be anxious about anything, but in
every situation, by prayer and petition, with
thanksgiving, present your requests to God.**

New International Version

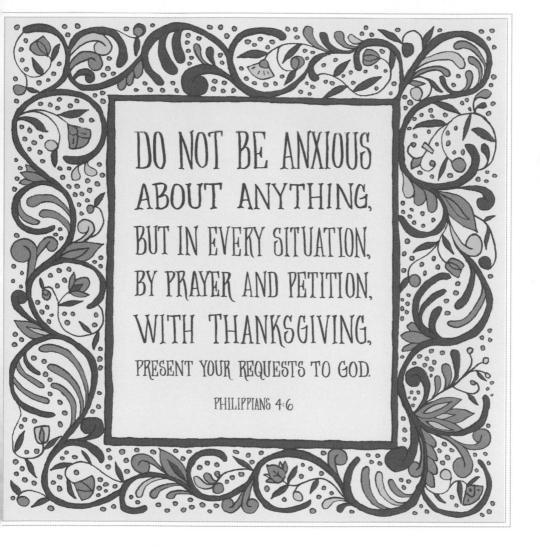

DO NOT BE ANXIOUS ABOUT ANYTHING, BUT IN EVERY SITUATION, BY PRAYER AND PETITION, WITH THANKSGIVING, PRESENT YOUR REQUESTS TO GOD.

PHILIPPIANS 4:6

Finally, Brothers & Sisters,

Whatever is TRUE, Whatever i

Whatever is PURE, Whatever i

—If anythin

Think

Noble, whatever is Right,

ovely, whatever is Admirable

s Excellent or Praiseworthy—

bout such things.

Phil 4:8 NIV

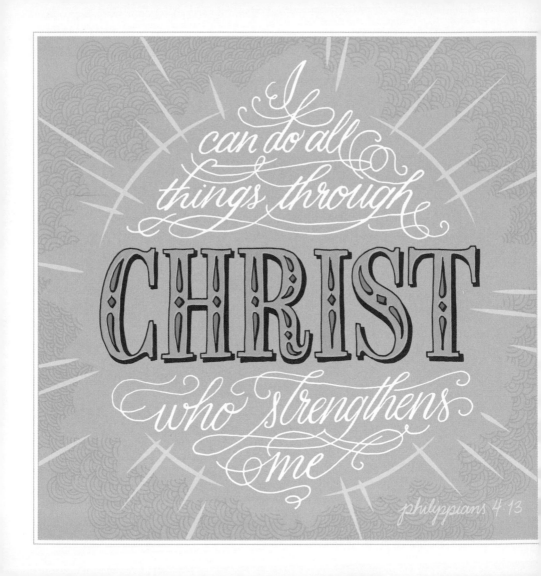

12b Everywhere and in all things I have learned both to be full and to be hungry, both to abound and to suffer need.

13 I can do all things through Christ who strengthens me.

New King James Version

13 He has rescued us from the power of darkness and transferred us into the kingdom of his beloved Son,

14 in whom we have redemption, the forgiveness of sins.

15 He is the image of the invisible God, the firstborn of all creation;

16 for in him all things in heaven and on earth were created, things visible and invisible, whether thrones or dominions or rulers or powers—all things have been created through him and for him.

17 He himself is before all things, and in him all things hold together.

18 He is the head of the body, the church; he is the beginning, the firstborn from the dead, so that he might come to have first place in everything.

19 For in him all the fullness of God was pleased to dwell,

20 and through him God was pleased to reconcile to himself all things, whether on earth or in heaven, by making peace through the blood of his cross.

New Revised Standard Version

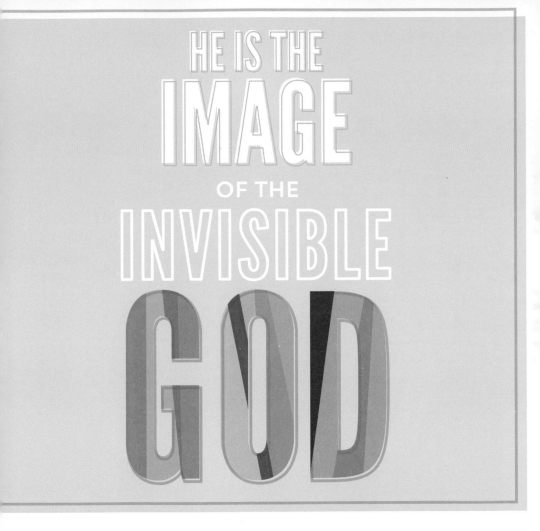

HE IS THE
IMAGE
OF THE
INVISIBLE
GOD

COLOSSIANS 1:15

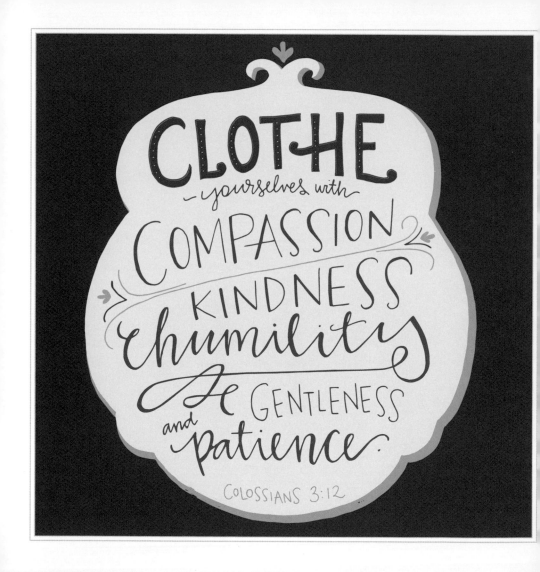

12 Therefore, as God's chosen people, holy and dearly loved, **clothe yourselves with compassion, kindness, humility, gentleness and patience.**
13 Bear with each other and forgive one another if any of you has a grievance against someone. Forgive as the Lord forgave you.
14 And over all these virtues put on love, which binds them all together in perfect unity.
15 Let the peace of Christ rule in your hearts, since as members of one body you were called to peace. And be thankful.

New International Version

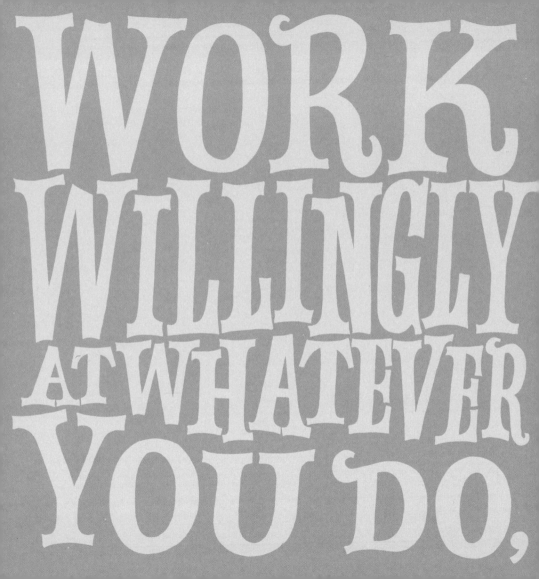

AS THOUGH YOU WERE
WORKING
FOR THE
LORD
RATHER THAN FOR
PEOPLE.
COLOSSIANS 3:23 NLT

**7 For God has not given us a spirit of fear and
timidity, but of power, love, and self-discipline.**
8 So never be ashamed to tell others about our
Lord. And don't be ashamed of me, either, even
though I'm in prison for him. With the strength
God gives you, be ready to suffer with me for the
sake of the Good News.
9 For God saved us and called us to live a holy life.
He did this, not because we deserved it, but because
that was his plan from before the beginning of
time—to show us his grace through Christ Jesus.

New Living Translation

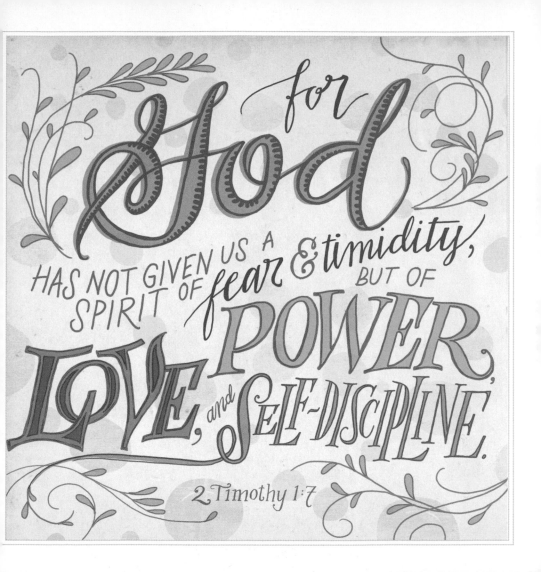

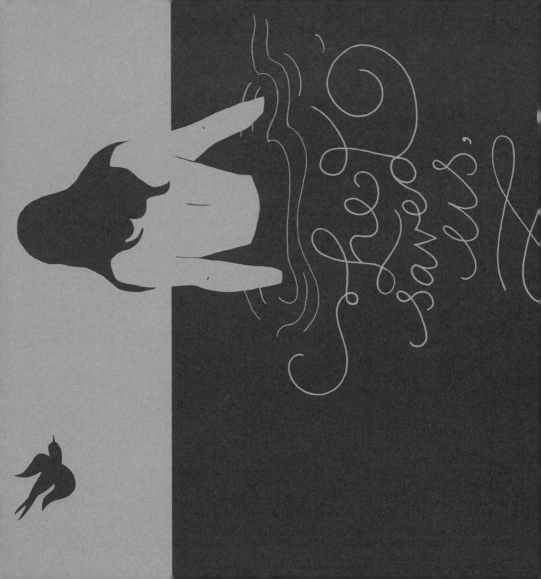

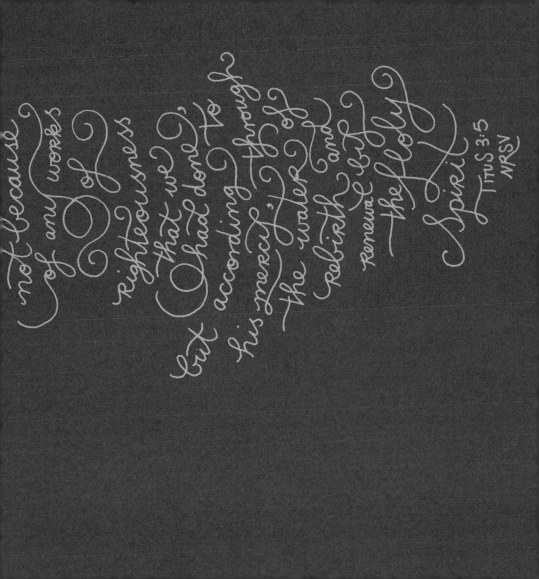

not because of any works of righteousness that we had done, but according to his mercy, through the water of rebirth and renewal by the Holy Spirit.

Titus 3:5
NRSV

12 For **the word of God is living and active** and sharper than any two-edged sword, and piercing as far as the division of soul and spirit, of both joints and marrow, and able to judge the thoughts and intentions of the heart.

13 And there is no creature hidden from His sight, but all things are open and laid bare to the eyes of Him with whom we have to do.

New American Standard Bible

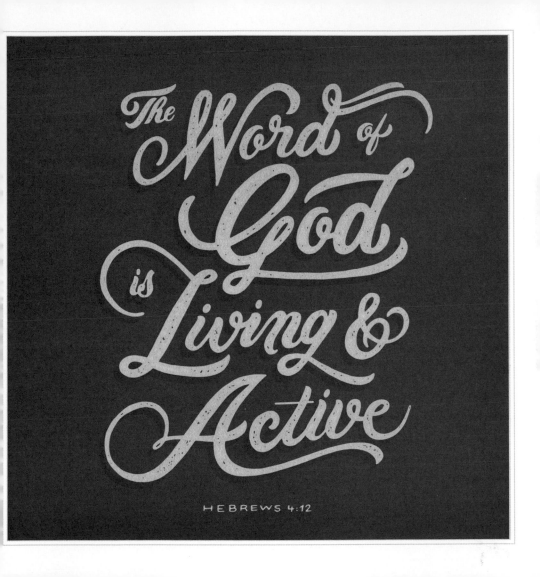

1 Now **faith is the assurance of things hoped for, the conviction of things not seen.**

2 For by it the men of old gained approval.

3 By faith we understand that the worlds were prepared by the word of God, so that what is seen was not made out of things which are visible.

New American Standard Bible

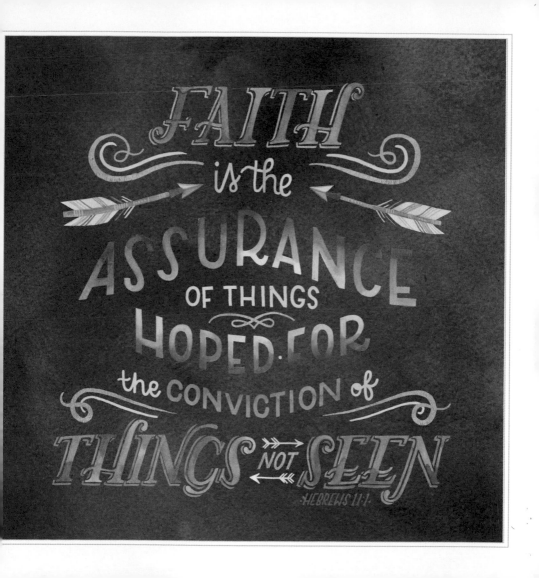

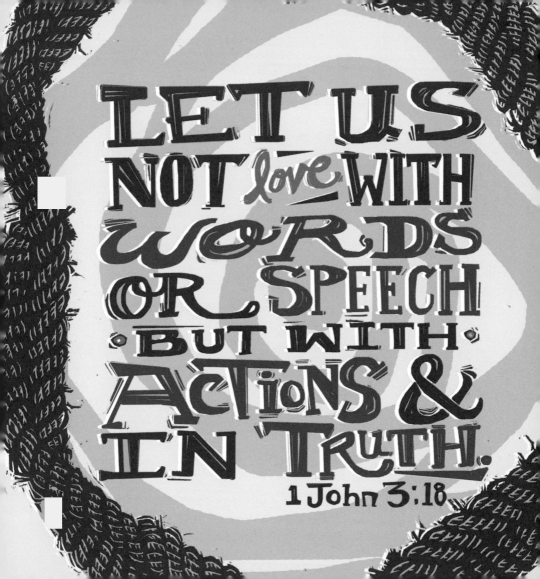

16 This is how we know what love is: Jesus Christ laid down his life for us. And we ought to lay down our lives for our brothers and sisters.

17 If anyone has material possessions and sees a brother or sister in need but has no pity on them, how can the love of God be in that person?

18 Dear children, **let us not love with words or speech but with actions and in truth.**

19 This is how we know that we belong to the truth and how we set our hearts at rest in his presence:

20 If our hearts condemn us, we know that God is greater than our hearts, and he knows everything.

21 Dear friends, if our hearts do not condemn us, we have confidence before God

22 and receive from him anything we ask, because we keep his commands and do what pleases him.

23 And this is his command: to believe in the name of his Son, Jesus Christ, and to love one another as he commanded us.

24 The one who keeps God's commands lives in him, and he in them. And this is how we know that he lives in us: We know it by the Spirit he gave us.

New International Version

15 Whoever confesses that Jesus is the Son of God, God abides in him, and he in God.

16 We have come to know and have believed the love which God has for us. God is love, and the one who abides in love abides in God, and God abides in him.

17 By this, love is perfected with us, so that we may have confidence in the day of judgment; because as He is, so also are we in this world.

18 There is no fear in love; but perfect love casts out fear, because fear involves punishment, and the one who fears is not perfected in love.

19 We love, because He first loved us.

20 If someone says, "I love God," and hates his brother, he is a liar; for the one who does not love his brother whom he has seen, cannot love God whom he has not seen.

21 And this commandment we have from Him, that the one who loves God should love his brother also.

New American Standard Bible

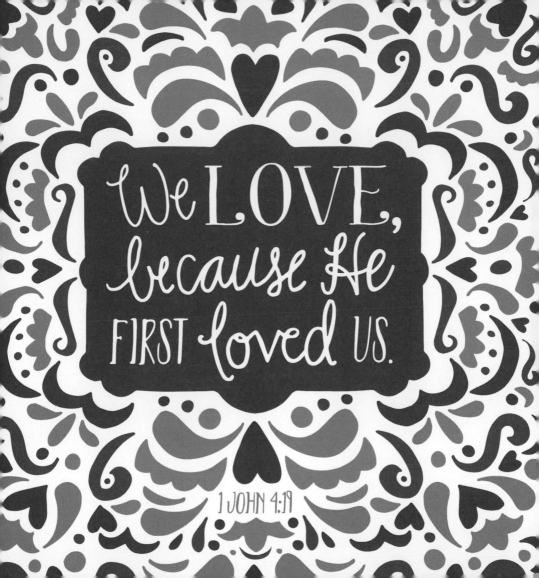

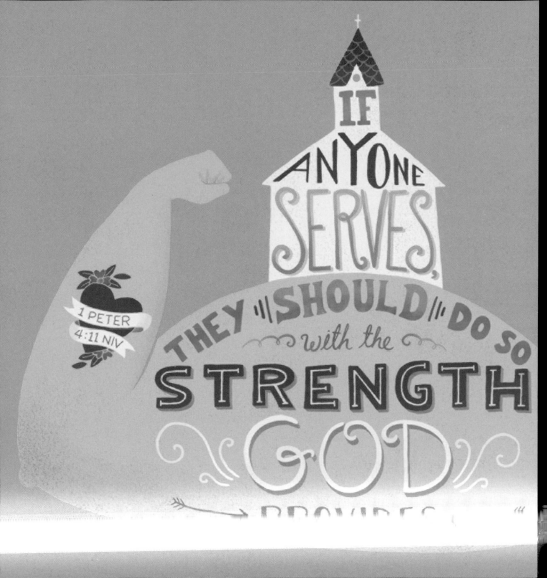

IF
ANYONE
SERVES,
THEY "SHOULD" DO SO
with the
STRENGTH
GOD
PROVIDES

1 PETER
4:11 NIV

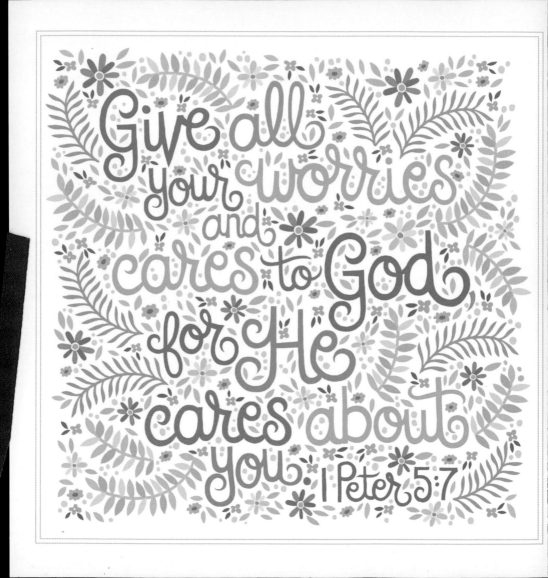

Give all your worries and cares to God for He cares about you. 1 Peter 5:7

5b "God opposes the proud

but gives grace to the humble."

6 So humble yourselves under the mighty power of God, and at the right time he will lift you up in honor.

7 Give all your worries and cares to God, for he cares about you.

8 Stay alert! Watch out for your great enemy, the devil. He prowls around like a roaring lion, looking for someone to devour.

9 Stand firm against him, and be strong in your faith. Remember that your family of believers all over the world is going through the same kind of suffering you are.

New Living Translation

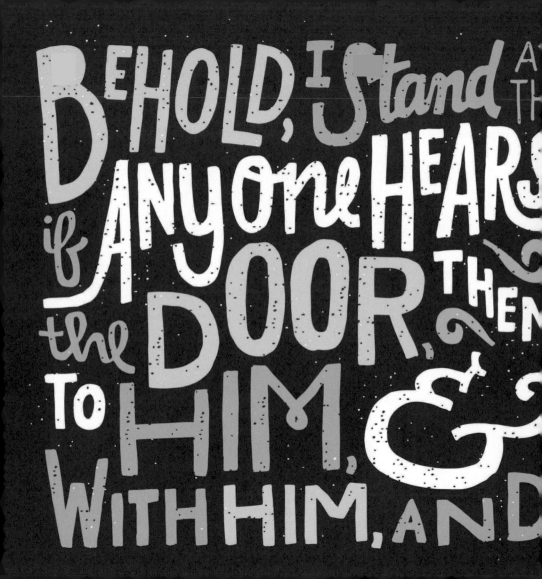

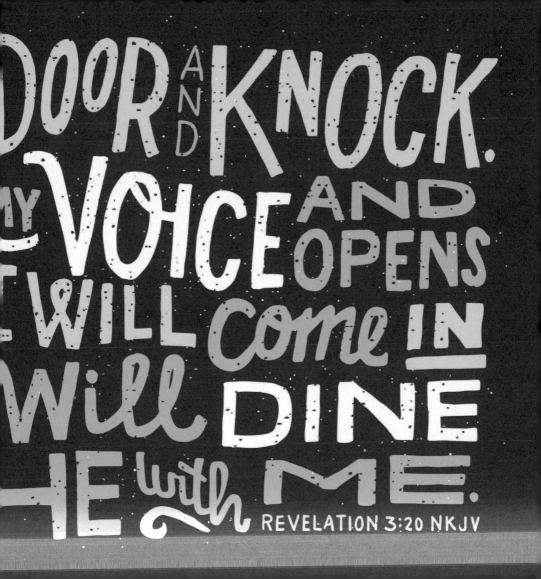

1 I saw a new heaven and a new earth: for the first heaven and the first earth have passed away, and the sea is no more.

2 I saw the holy city, New Jerusalem, coming down out of heaven from God, prepared like a bride adorned for her husband.

3 I heard a loud voice out of heaven saying, "Behold, God's dwelling is with people, and he will dwell with them, and they will be his people, and God himself will be with them as their God.

4 He will wipe away from them every tear from their eyes. Death will be no more; neither will there be mourning, nor crying, nor pain, any more. The first things have passed away."

World English Bible

I saw a new heaven and a new earth: for the first heaven and the first earth have passed away, and the sea is no more.

Revelation 21:1

About the Artists

Jaclyn Atkinson is a printmaker from Appalachian Virginia currently living the dream as an artist/designer in Brooklyn. She is most passionate about relief printing and happiest when carving wood, baking pie, crafting costumes, or practicing yoga. See more of her work at newjacktale.com. **(pages 70–71, 157, 158, 192)**

Sarah Lynn Baker illustrates with quill and ink, pencil, and Photoshop, and draws inspiration from dreams, her daughter, childhood memories, and all the illustrators/friends she meets through her work for SCBWI. Sarah lives in Los Angeles with her old man and young daughter and their mostly feral cat, Bill. **(pages 55, 98, 154–155)**

Stephanie Baxter is an illustrator and hand letterer living and working in Leeds, UK. Steph works both traditionally with pen, paper, and ink, as well as digitally, to create her illustrations and hand lettering. When she isn't working, Steph can usually be found drinking tea or being by the sea. **(pages 16, 52, 95, 162–163)**

Caitlin Bristow, the creative behind Lettered Life, jumped into the world of hand-lettering in 2013. Her modern script and love of flourish bring a personal touch to her paper goods and home décor designs. She's blessed to the brim and loves creating from her home studio in Charlotte, NC. **(pages 10, 60–61, 125, 174)**

Becca Cahan is a Boston-based illustrator and letterer who graduated from MassArt in 2013. After learning watercolor painting at a young age, she dabbled in other media but always came back to her love of watercolors. Her paintings demonstrate a passion for lettering and love of pattern and color. **(pages 34–35, 88, 141, 191)**

Veronica Chen is an illustrator and professional daydreamer. She suffers from the travel bug and finds herself in a foreign country at least once a year, which is a major inspiration in her art, as is her fascination for cryptozoology and all things peculiar. She loves dark chocolate, dark humor, and a dog named Lulu. Find more of her work at veronicachen.com. **(pages 36, 48–49, 69, 129, 196–197)**

Vidhi Dattani is a multidisciplinary designer who works in digital, print, and fine art across many industries including marketing, advertising, and retail. She is particularly passionate about illustration, typography, and calligraphy. Vidhi lives in New York City, but considers Paris her spiritual home, and loves all things French. **(pages 40–41, 75, 106, 147)**

Vaughn Fender is an artist residing in the Northeast U.S. Born in Kingston, Jamaica, he is inspired by vibrant colors, bustling streets, and music with good vibes. **(pages 45, 92, 138, 200–201)**

Erynn Alice Hesler is a designer and illustrator hailing from Kansas City, Missouri, currently based in San Francisco, California. You can see more of her work on dribbble.com/erynnalice or at erynnalice.com. **(pages 8–9, 63, 121, 179)**

Lindsay Hodson is a hand lettering artist and graphic designer who runs Hey Normal Day Shop from her

studio outside Portland, Oregon. She spends her days making art, playing with her 4-year-old daughter, and drinking entirely too much coffee. Find her work at etsy.com/heynormaldayshop. **(pages 30, 84–85, 135, 180)**

Artist and illustrator **Lindsay Hopkins** has been creating since childhood. She has a love of color and hopes to encourage and inspire others through her creativity. Lindsay works out of her bright home studio in Georgia creating inspirational art prints and stationery. Find more of her work at pen-and-paint.com. **(pages 15, 58–59, 115, 169, 195)**

Zachary Horst is a designer, letterer, and illustrator living just north of Austin in Georgetown, Texas, with his partner, Taylor, and their cat, Cy. His favorite things to do are to experiment with typography and explore new places. You can contact him and find his other work at zacharyhorst.com. **(pages 4, 23, 66–67, 122, 176)**

Kristi Smith is the senior illustrator of **Juicebox Designs**, where she works with her husband and creative director, Jay Smith. In addition to her illustration skills, her hand-lettering styles give the company a unique and diversified advantage in the marketplace. Their work can be viewed at juiceboxdesigns.com. **(pages 24–25, 72, 132, 185)**

Caitlin Keegan is a freelance illustrator and designer whose clients include Abrams, Chronicle Books, and Storey Publishing. She previously worked as a designer for Sesame Workshop and *Nickelodeon Magazine*. Caitlin's work has been recognized by American Illustration and included in several collections and anthologies. She is a graduate of the Rhode Island

School of Design and lives and works in Brooklyn, New York. **(pages 7, 56, 112–113, 161)**

Clair Rossiter is a freelance illustrator based in the UK. She graduated in 2014 with a degree in illustration from Falmouth University. She especially enjoys painting and collaging, inventing new characters, and hand-rendered typography. To see more of her work, pop over to clairrossiter.com. **(pages 39, 96–97, 142, 203)**

Beth Rufener is a graphic designer, writer, musician, and typography enthusiast who's been an artist since first grade. Now she designs fonts and enjoys drawing letters. Scripture is her favorite artistic subject. She lives in Ohio with her husband and two children. Visit her blog and say hello! creatifolio.wordpress.com. **(pages 20, 81, 131, 166)**

Established in 2010, **Satchel & Sage** is the collective work of Morgana and Gerren Lamson, a husband-and-wife creative team living in Austin, Texas. Their products are a collection of colorfully designed printed goods and textiles that incorporate hand-drawn typography, playful illustrations, and sophisticated patterns. **(pages 109, 148)**

Karolin Schnoor is a German illustrator based in London. Her love of screenprinting, folklore, and flat color inform her work. She works primarily as an editorial illustrator but also runs an online shop selling art prints and stationery. Her work can be found at karolinschnoor.co.uk. **(pages 46, 110, 152, 186)**

Marlene Silveira is a multidisciplinary designer by day and a letterer/illustrator by night, working and

living in Toronto, Canada. Marlene is a passionate, typography-obsessed workaholic, running on coffee and no sleep. **(pages 29, 82, 136–137, 189)**

Angela Sue Southern is a letterer and typographic illustrator based in Austin, Texas, although her heart will always belong to Northern Michigan. Her lettering can be found in a wide variety of publications. She enjoys flea markets, cantaloupe sorbet, and reading the memoirs of comedians. **(pages 12–13, 64, 116, 164)**

This Paper Ship is Joel and Ashley Selby, a husband-and-wife freelance illustration team who met in a freshman drawing class and have worked side by side ever since. They're in love with imagination and storytelling. In their free time they watch movies, go on adventures, and cuddle their four cats. **(pages 19, 87, 126, 182)**

Lindsay Whitehead, of Unraveled Design, is an independent artist currently residing in the suburbs of Houston, Texas. Lindsay dabbles in many forms of creative expression but perhaps is best known for her upbeat and colorful quote illustrations. She draws inspiration from many places including vintage fabric, folk art, and floral embroidery. Her whimsical lettering, rich floral motifs, and energetic color stories are what make Lindsay's art harmonize so well with positive and inspiring quotations. You can find her work at unraveleddesign.com. **(pages 26, 91, 144–145, 198)**

Kate Whitley is an illustrator and surface designer. She is influenced by European folk art and textiles, American quilts, and vintage silk scarves. Kate runs her own paper goods business called Little Things Studio. Kate lives in Nashville, Tennessee, with her husband, Dave, and two cats. Find more of her work at littlethingsstudio.com. **(pages 33, 78, 118–119, 173)**

Wendy Xu is a letterer, illustrator, and typographic designer based in California. Her passion for letterforms has led her to explore a variety of styles, from calligraphic expressions and digital type to illustrative lettering. Her work has been recognized by the Type Directors Club with the Certificate of Typographic Excellence. **(pages 3, 51, 100–101, 151)**

Tae Won Yu is an artist, musician, and designer based in Brooklyn. Some of his work includes playing in the seminal 90s indie rock band Kicking Giant, designing record covers for Built to Spill, and creating paper sculptures, which were featured in his solo show at the Land Gallery in Portland in 2012. His recent work can be found at taewonyu.tumblr.com. **(pages 42, 76–77, 105, 170)**

A WORD OF EXPLANATION

Many contemporary translations of the Bible do not capitalize pronouns such as "he" and "him," because these words were not capitalized in the original Greek and Hebrew texts. While many of us think that capital letters show reverence for God, the translators opted for fidelity to the original usage. We have decided to remain true to the translation with regard to capitalization, as well as other grammar and punctuation.